THE GRAMMAR OF ORNAMENT

ALL 100 COLOR PLATES FROM
THE FOLIO EDITION OF THE
GREAT VICTORIAN SOURCEBOOK
OF HISTORIC DESIGN

Owen Jones

DOVER PUBLICATIONS, INC.
New York

Published in Canada by General Publishing Company, Ltd.,
30 Lesmill Road, Don Mills, Toronto, Ontario.
Published in the United Kingdom by Constable and Company, Ltd.,
10 Orange Street, London WC2H 7EG.

This Dover edition, first published in 1987, reproduces all 100 color plates
from the folio edition of *The Grammar of Ornament* as published by Day and
Son, London, in 1856. The Publisher's Note and the captions (adapted from the
original) have been prepared specially for the present edition.

DOVER *Pictorial Archive* SERIES

Manufactured in the United States of America
Dover Publications, Inc.
31 East 2nd Street
Mineola, N.Y. 11501

Library of Congress Cataloging-in-Publication Data

Jones, Owen, 1809–1874.
The grammar of ornament.

(Dover pictorial archive series)
Reprint. Originally published: London : Day and Sons, 1856.
1. Decoration and ornament. I. Title. II. Series.
NK1510.J7 1987 745.4 87-13664
ISBN 0-486-25463-1 (pbk.)

Publisher's Note

Owen Jones (1809–1874) was born in London. After studies at the Royal Academy, he traveled to the Middle East and Spain. At Granada he was particularly attracted to the Alhambra and, between 1842 and 1845, he labored to produce *Plans, Elevations, Sections and Details of the Alhambra,* consisting of 101 color plates. Jones also executed book illustrations and engaged in interior design. It was probably his work with prefabricated buildings that led to his appointment, in 1851, as superintendent of works at the Great Exhibition. In 1852, Jones became supervisor of decoration when the Crystal Palace was reerected at Sydenham.

It is, however, for his monumental *The Grammar of Ornament* (1856) that Owen Jones is chiefly remembered. He set as his objective the publication of a collection of 90 plates of ornamental motifs from different civilizations that best demonstrated good design as defined by the 37 propositions, formulated by Jones, relating to purpose, form, proportion and application of color. The variety of sources from which Jones drew his material was staggering: Greek vases; Roman mosaics; Celtic manuscripts; medieval paintings and stained glass; Chinese porcelain, wood and fabrics; an illuminated Koran; Turkish mosques and tombs, to name but a few. The ten plates concluding the book were botanical drawings, for Jones held that nature was the ultimate source of good design and inspiration. Nature, however, was not to be copied directly, but had to be conventionalized to become effective decoration. In response to the mindless historicizing of many contemporary designers, Jones further stated that it was a mistake simply to copy conventionalized natural forms from other civilizations. Each culture had to reinterpret nature for its own ends.

As one of the first and most influential sourcebooks, *The Grammar of Ornament* doubtless did help to accomplish Jones's goal of a modern ornamentation: toward the end of the century Art Nouveau (which violates several of Jones's propositions) had pervasive influence, especially in the decorative arts. Even today *The Grammar of Ornament* fulfills its primary purpose magnificently.

Each of the book's 20 chapters began with an essay, ranging in length from two to 20 pages. Most were written by Jones; other authors were Matthew Digby Wyatt (Renaissance and Italian ornament), J. O. Westwood (Celtic ornament) and J. B. Waring (Byzantine and Elizabethan ornament). The entire text is omitted from the present edition for, although Jones was knowledgeable and some of what he says is in accord with modern perception, more than a century's research and scholarship have rendered it obsolete. He was perceptive enough to be among the first to value primitive art for purely aesthetic rather than anthropological reasons, but at the same time he was able to write: "The Chinese are totally unimaginative, and all their works are accordingly wanting in the highest grace of art,—the ideal." (Later realizing his error, Jones offered a corrective

in his 1867 *Examples of Chinese Ornament,* reprinted by Dover Publications as *Chinese Design and Pattern in Full Color,* 24204-8.)

In dealing with the enormous mass of material incorporated in *The Grammar of Ornament,* Jones relied both on primary and secondary sources. Many motifs came from the great collections in or near London to which he had direct access; some had been noted during his travels. (The Moorish motifs are, in fact, all from the Alhambra.) But Jones also had to rely heavily on printed works and casts. (It is hard for us to realize fully how limited pictorial references were when he began to fill the need with this book.)

The art for the plates was chiefly the work of two of Jones's pupils, Albert Warrent and Charles Aubert. Plate LXIX was by Thomas Talbot Bury. Plate XCVIII was the first published work of the young Christopher Dresser, destined to become one of the first industrial designers. His *Studies in Design* (1874–76) clearly shows the influence of Jones's theories. (A selection of plates has been reprinted by Dover Publications as *Authentic Victorian Decoration and Ornamentation in Full Color,* 25083-0.)

The Grammar of Ornament was originally published in installments to subscribers by Day and Son, London. Jones notes that it was completed in advance of schedule. A smaller-format edition of the book was published in 1865, but the quality of the plates in that and subsequent editions was markedly inferior to that of the original, which is here reproduced in reduction.

Because the original text has not been reprinted here, the reference numbers on the plates have been omitted where technically possible.

LIST OF PLATES

CHROMOLITHOGRAPH HALF TITLE TO THE FIRST EDITION

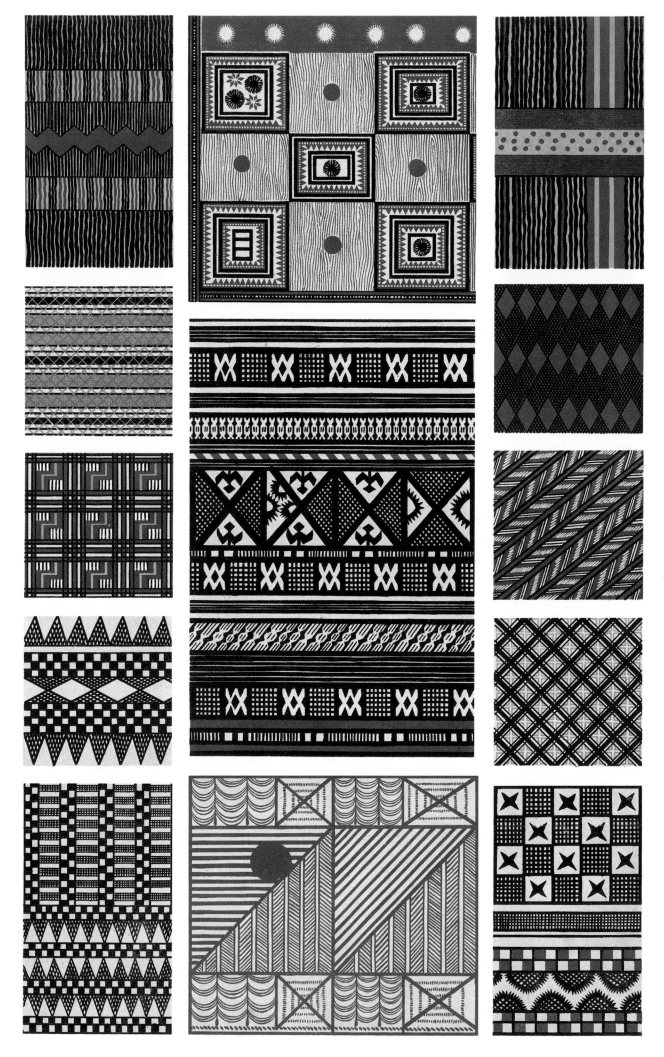

Plate I. ORNAMENT FROM OCEANIA.

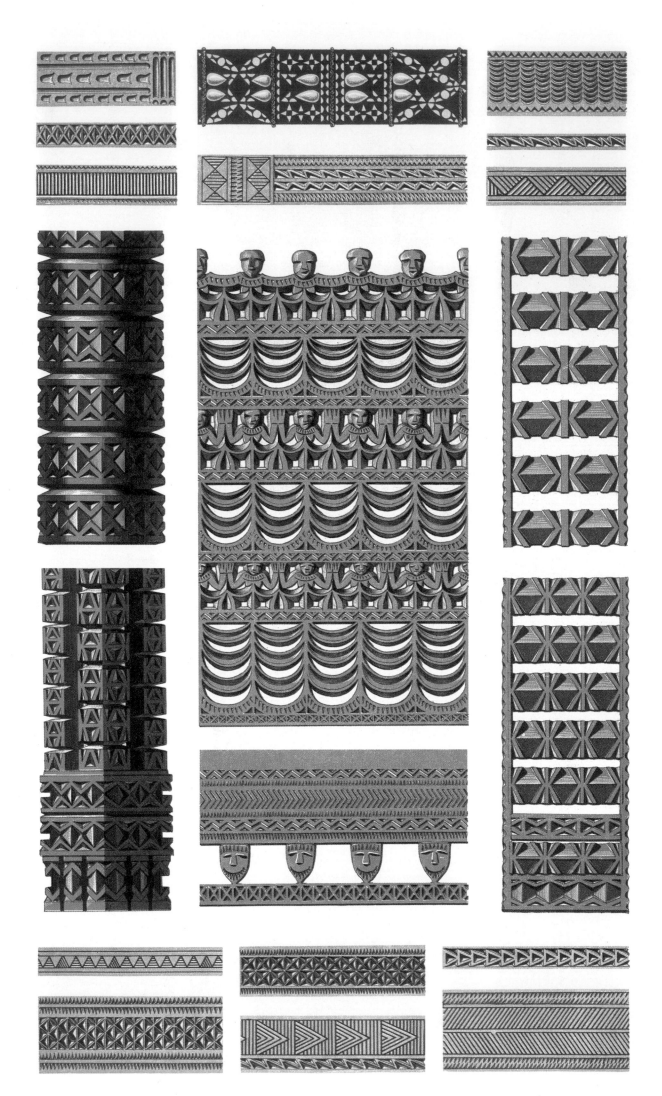

Plate II. ORNAMENT FROM OCEANIA.

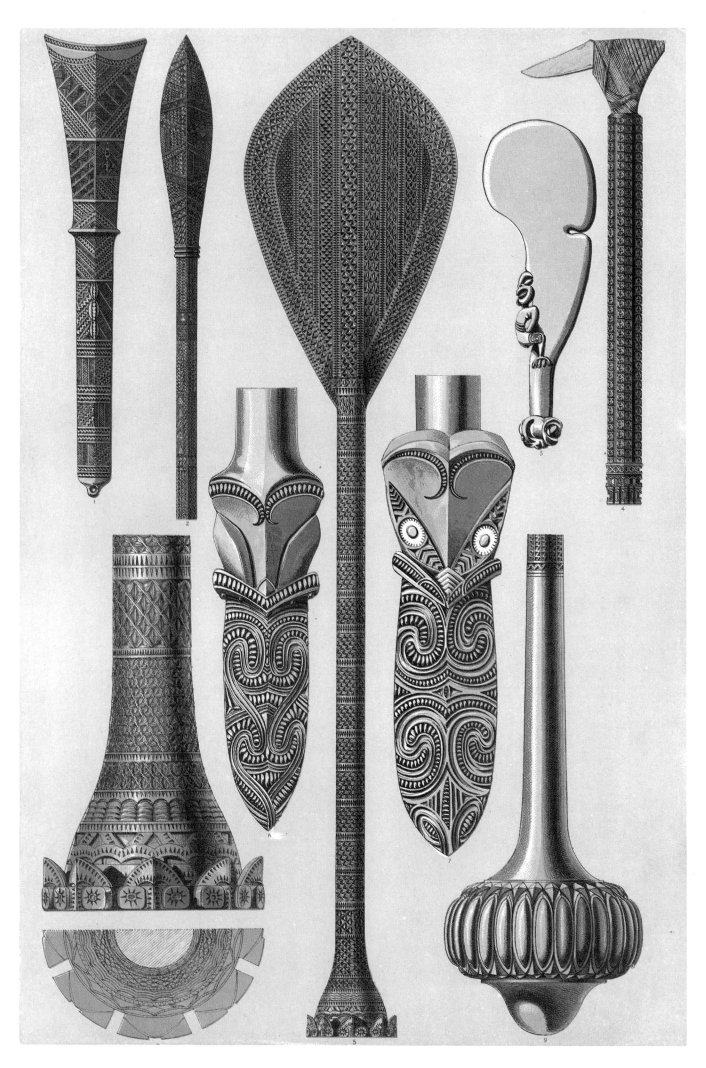

Plate III. Ornament from Oceania.

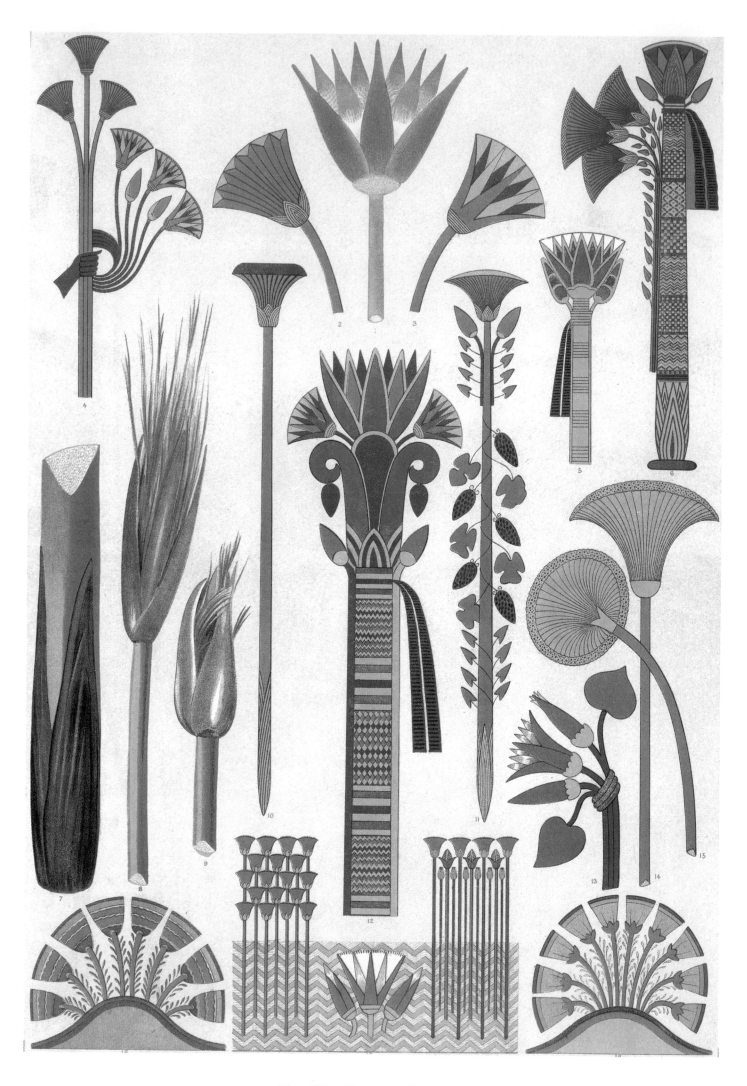

Plate IV. EGYPTIAN ORNAMENT.

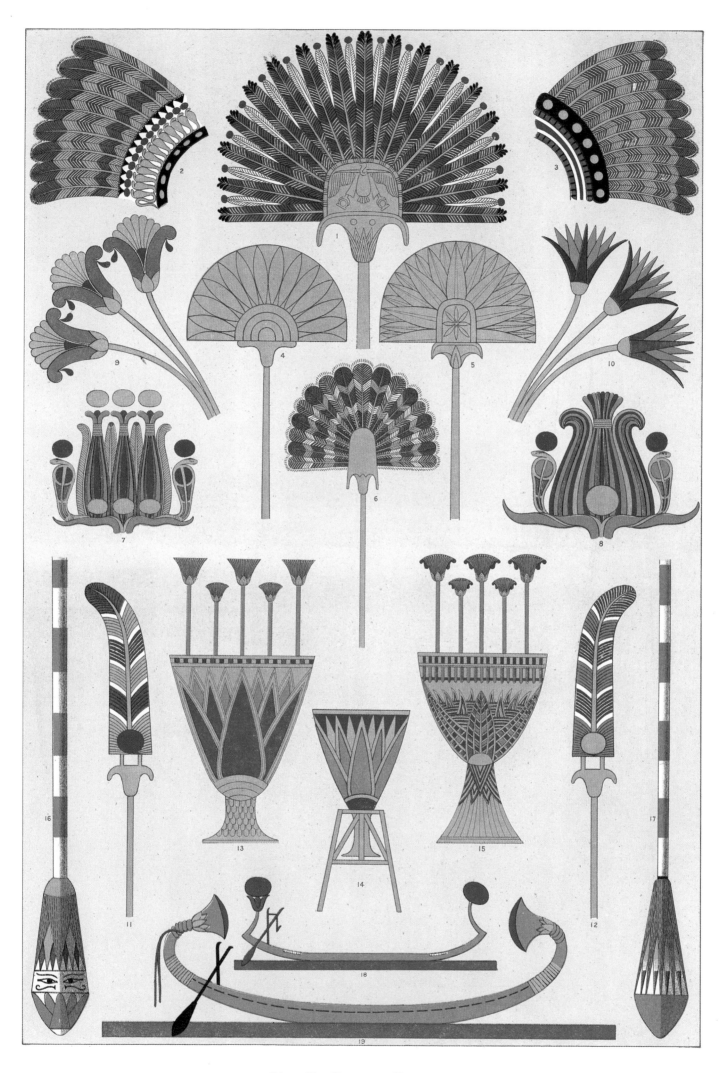

Plate V. Egyptian Ornament.

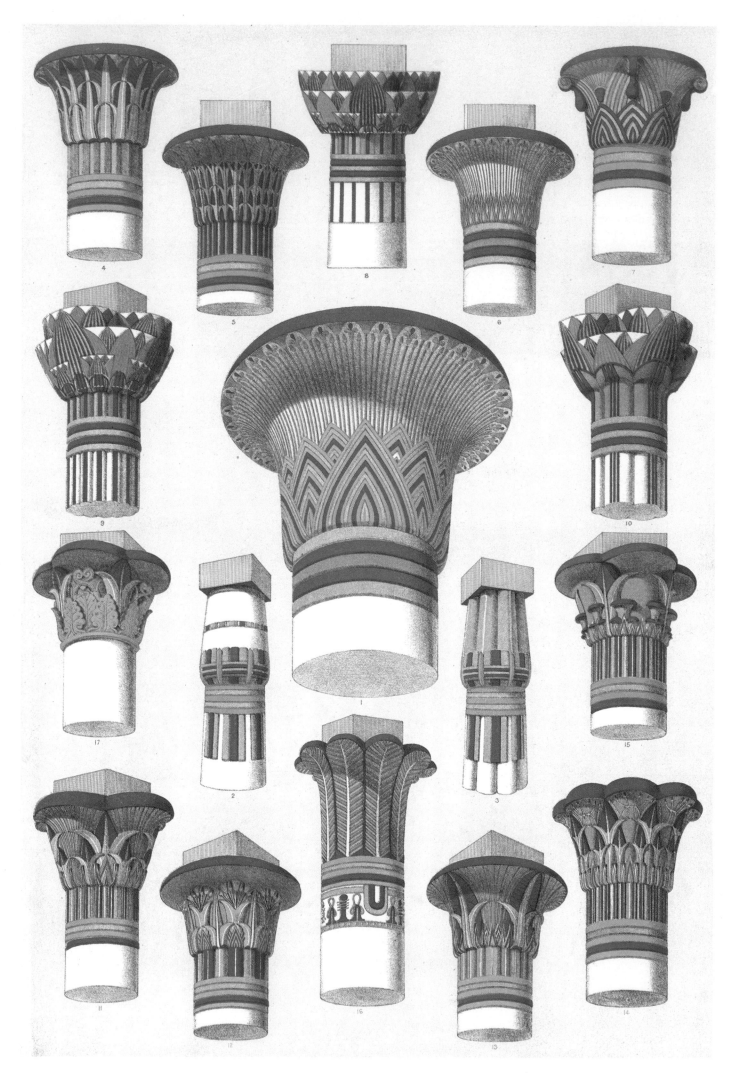

Plate VI. EGYPTIAN ORNAMENT.

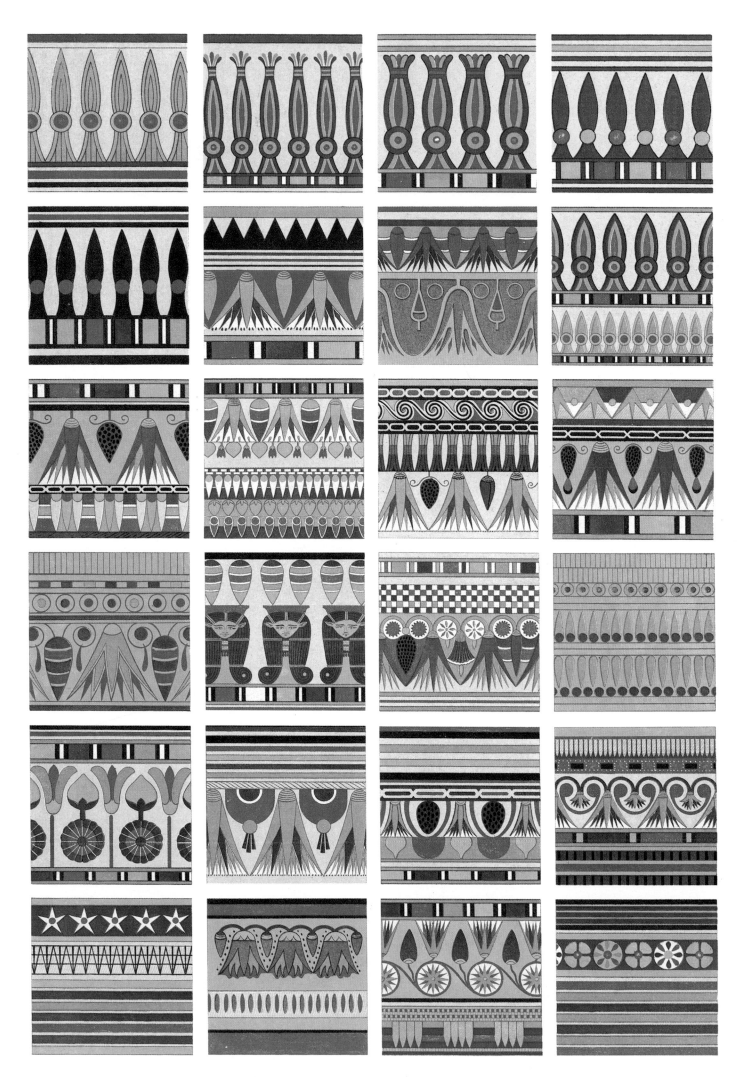

Plate VII. EGYPTIAN ORNAMENT.

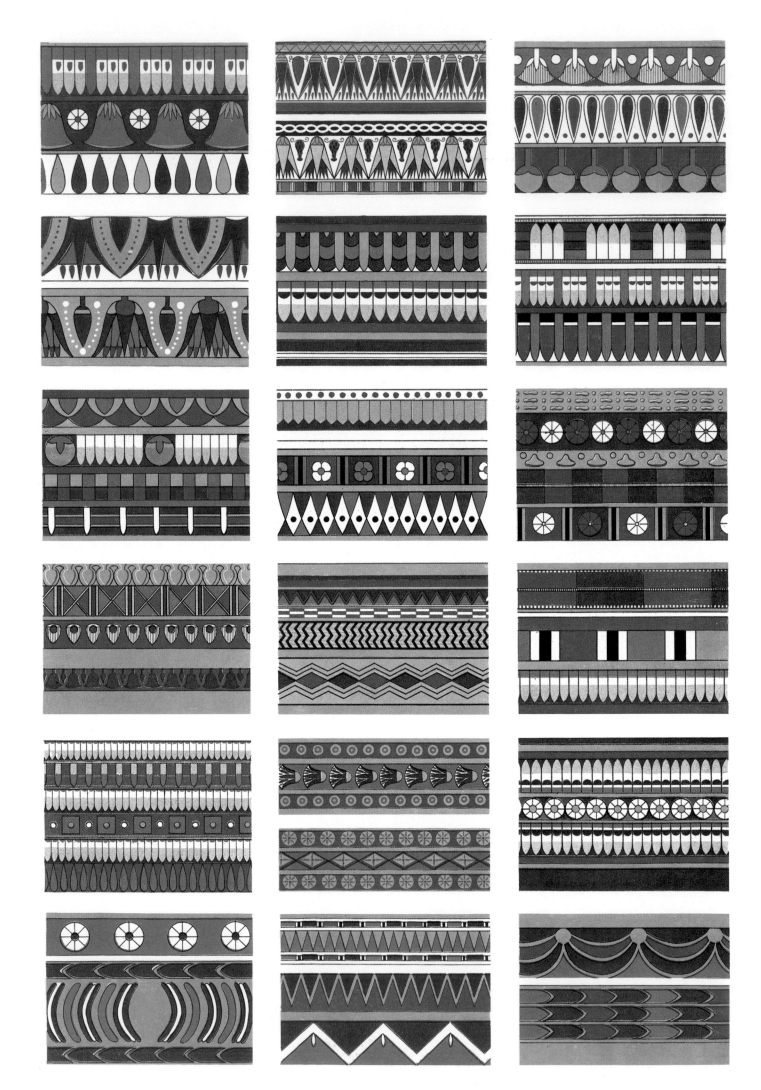

Plate VIII. EGYPTIAN ORNAMENT.

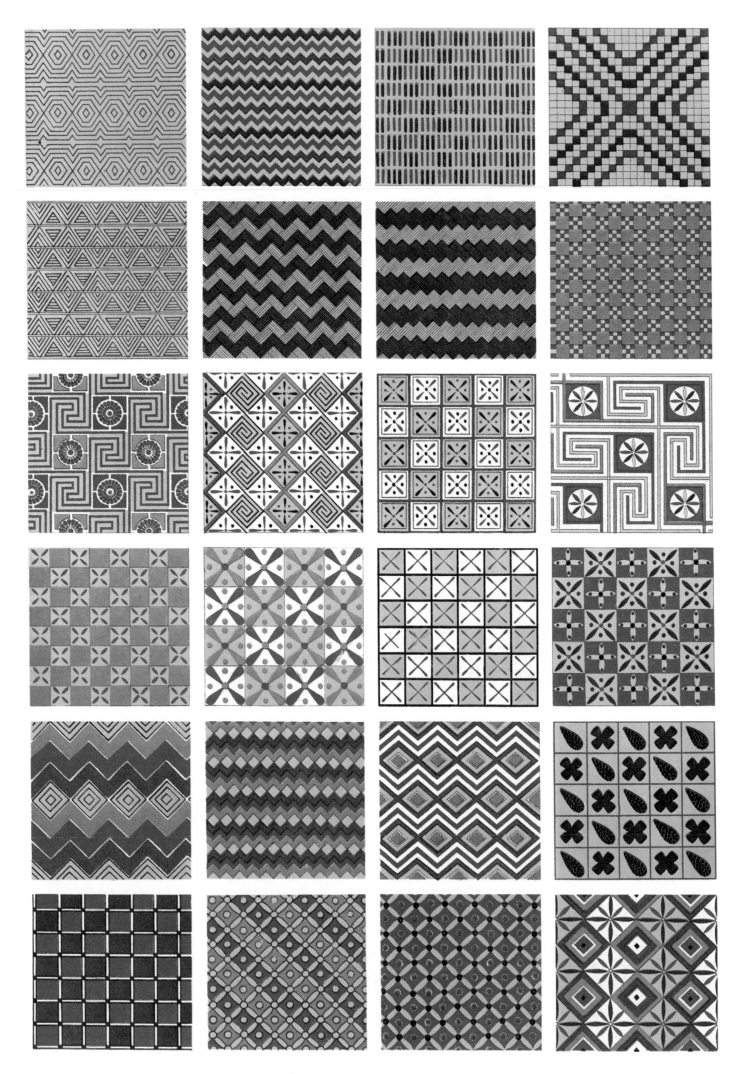

Plate IX. Egyptian Ornament.

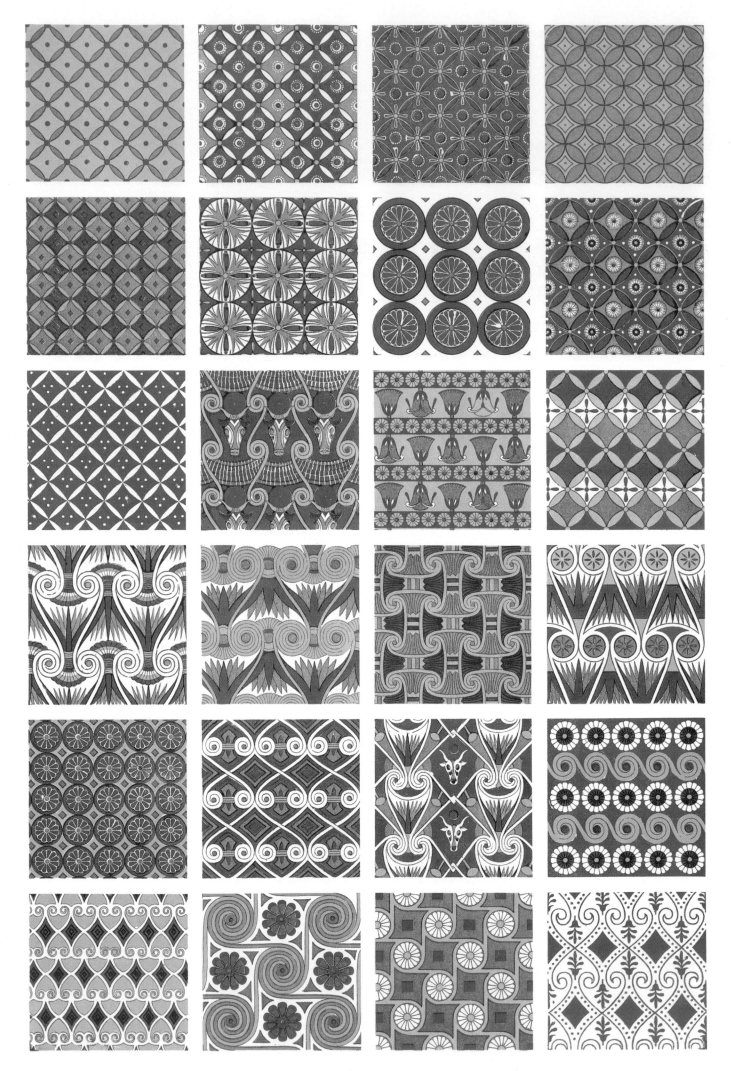

Plate X. Egyptian Ornament.

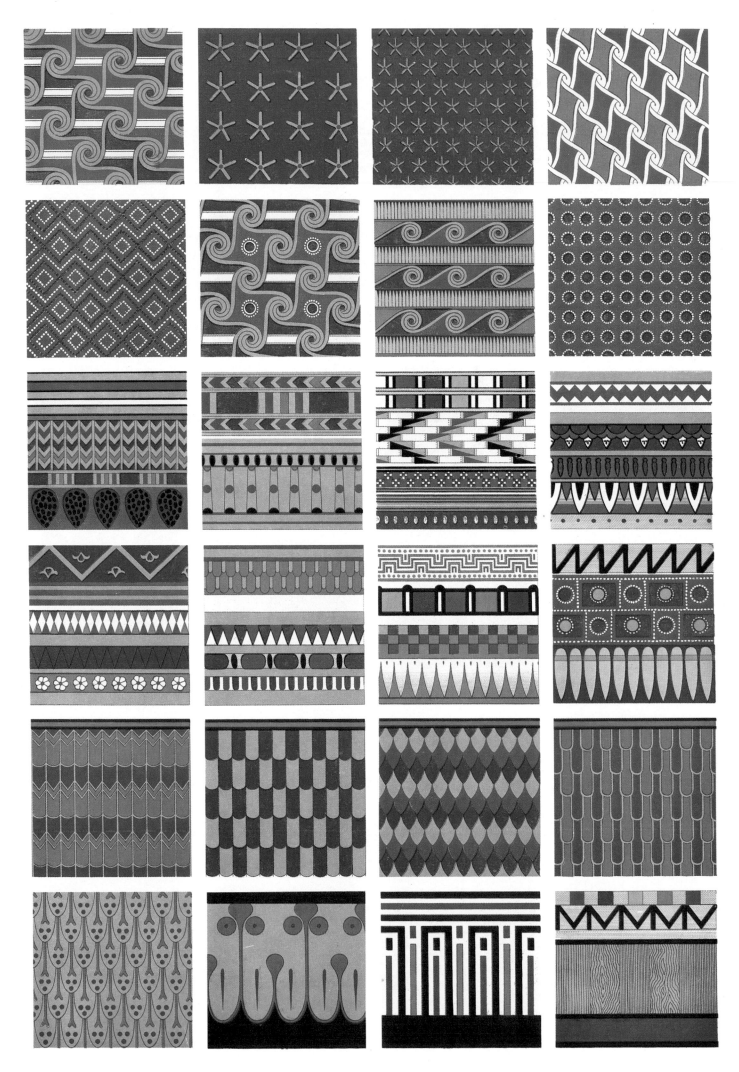

Plate XI. EGYPTIAN ORNAMENT.

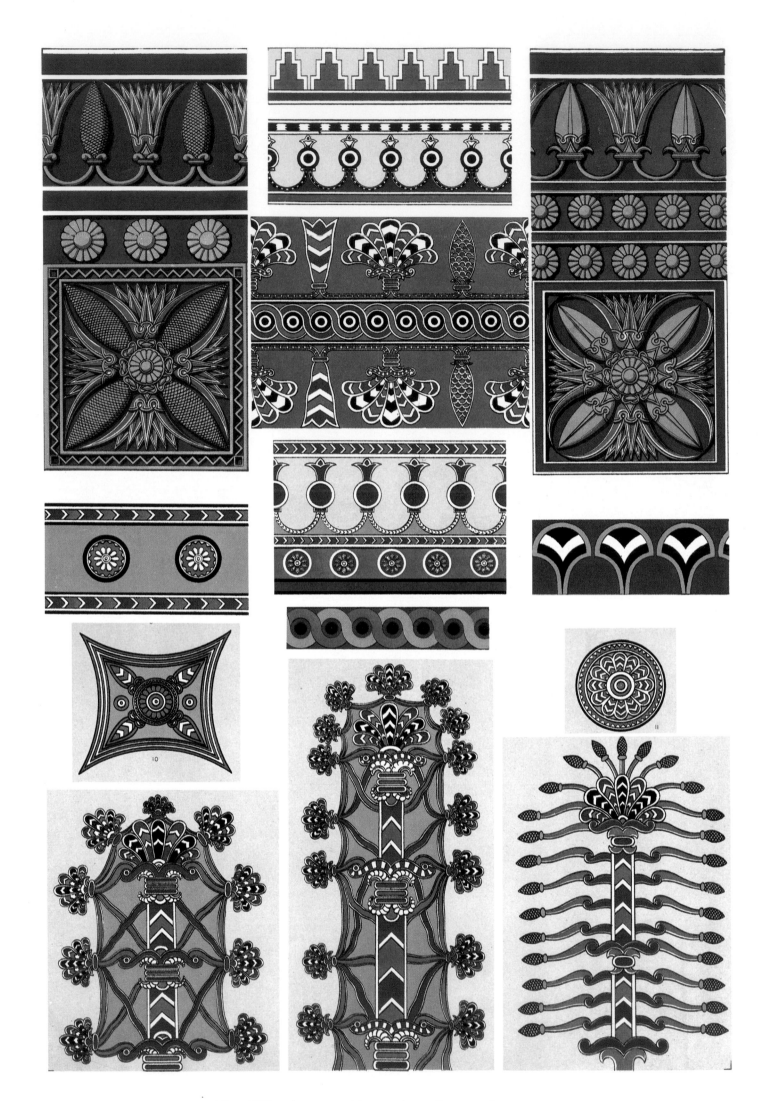

Plate XII. ASSYRIAN (NINEVEH) AND PERSIAN ORNAMENT.

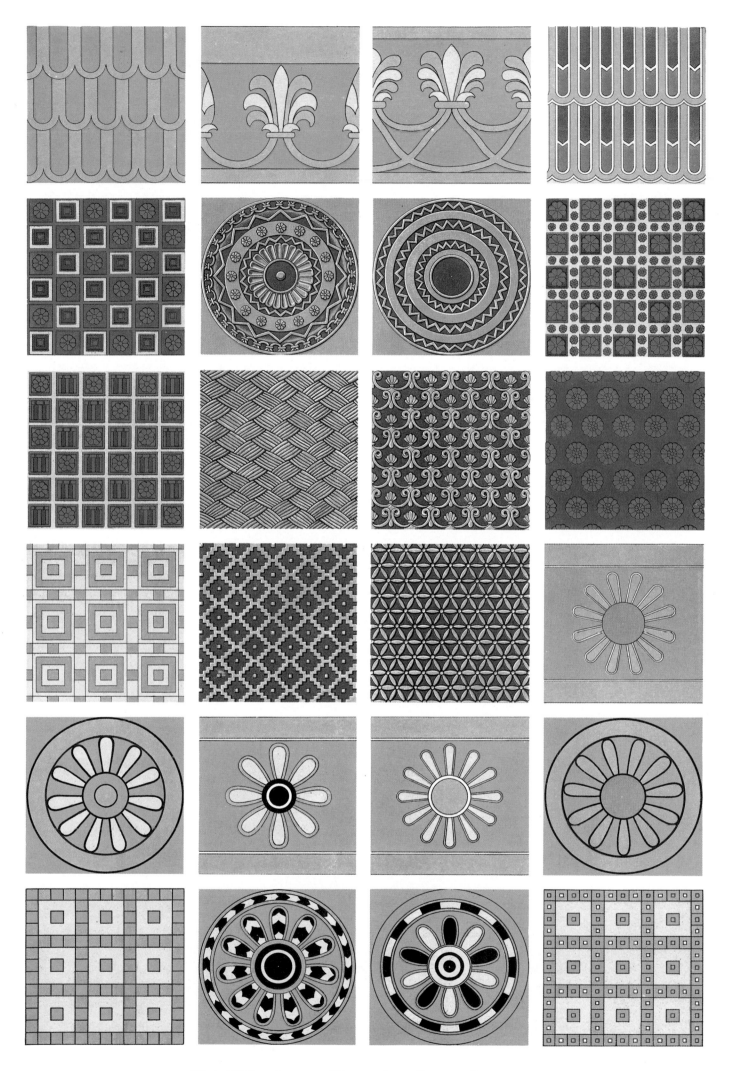

Plate XIII. ASSYRIAN (NINEVEH) AND PERSIAN ORNAMENT.

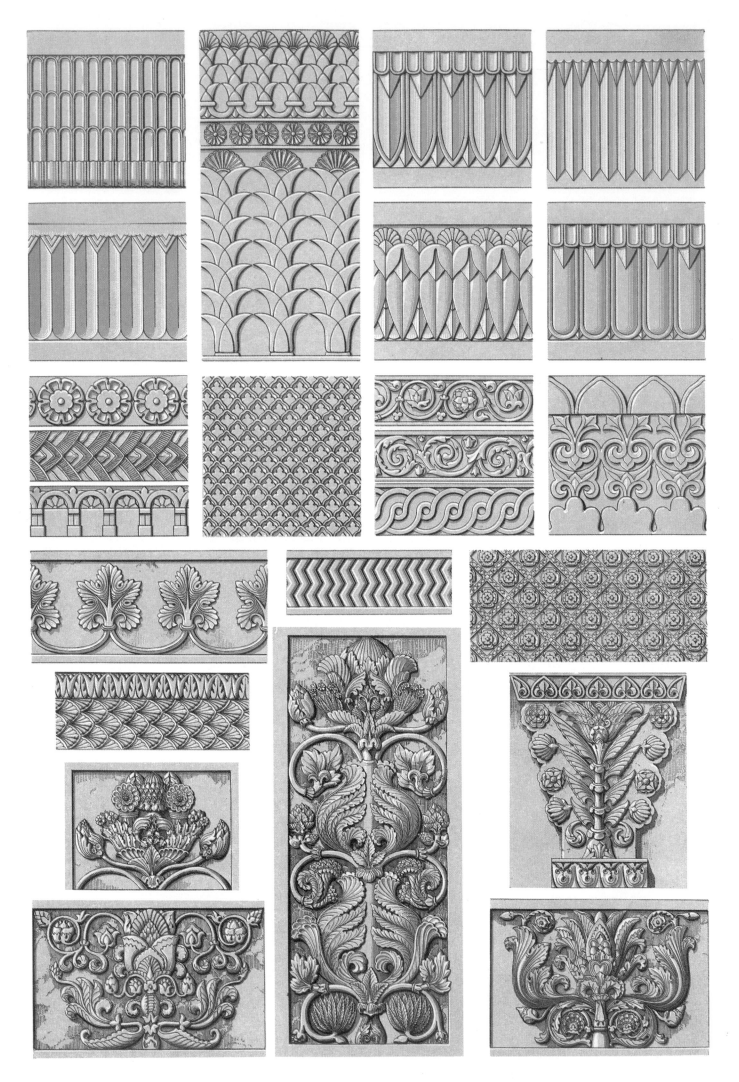

Plate XIV. Assyrian (Nineveh) and Persian Ornament.

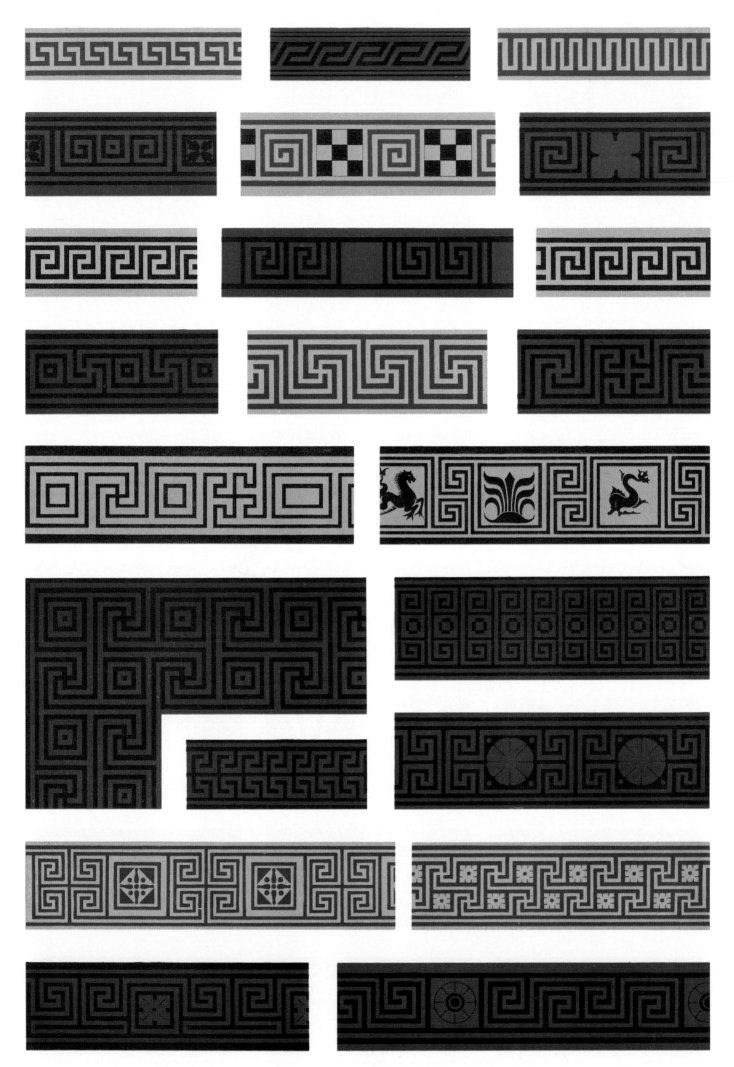

Plate XV. Greek Ornament.

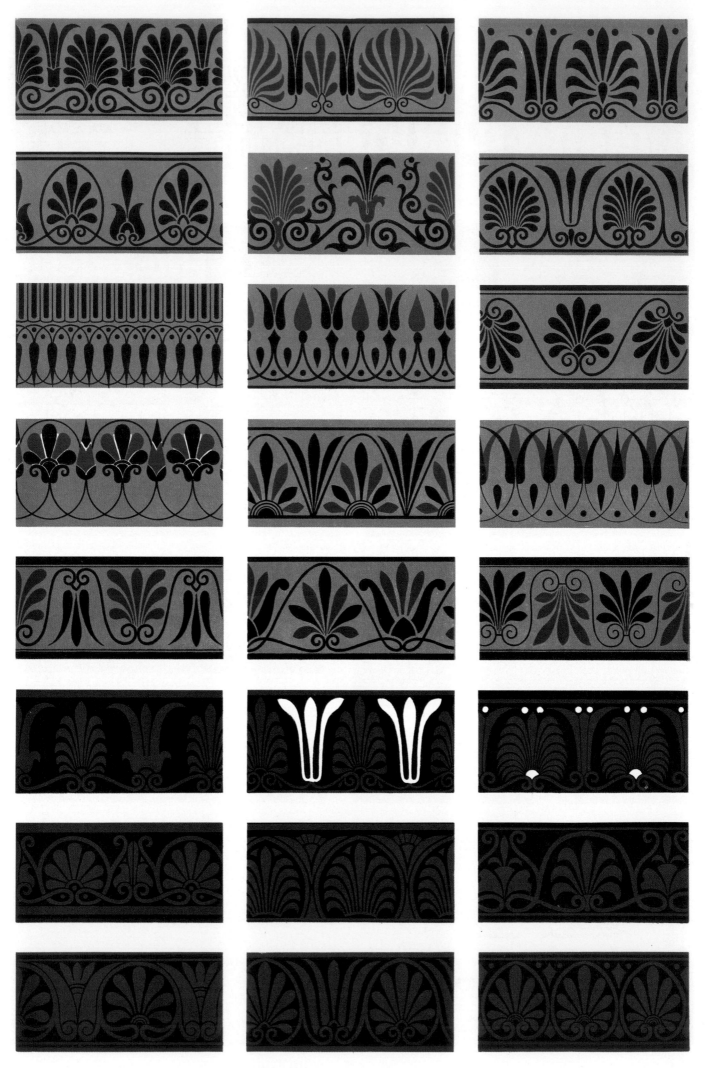

Plate XVI. GREEK ORNAMENT.

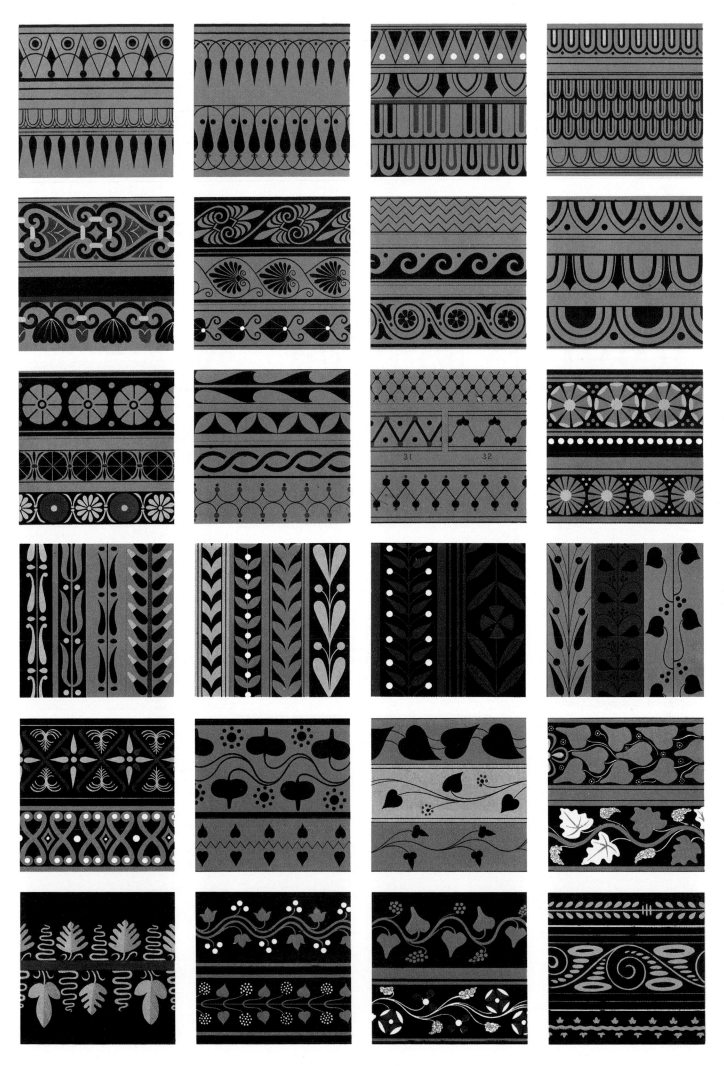

Plate XVII. GREEK ORNAMENT.

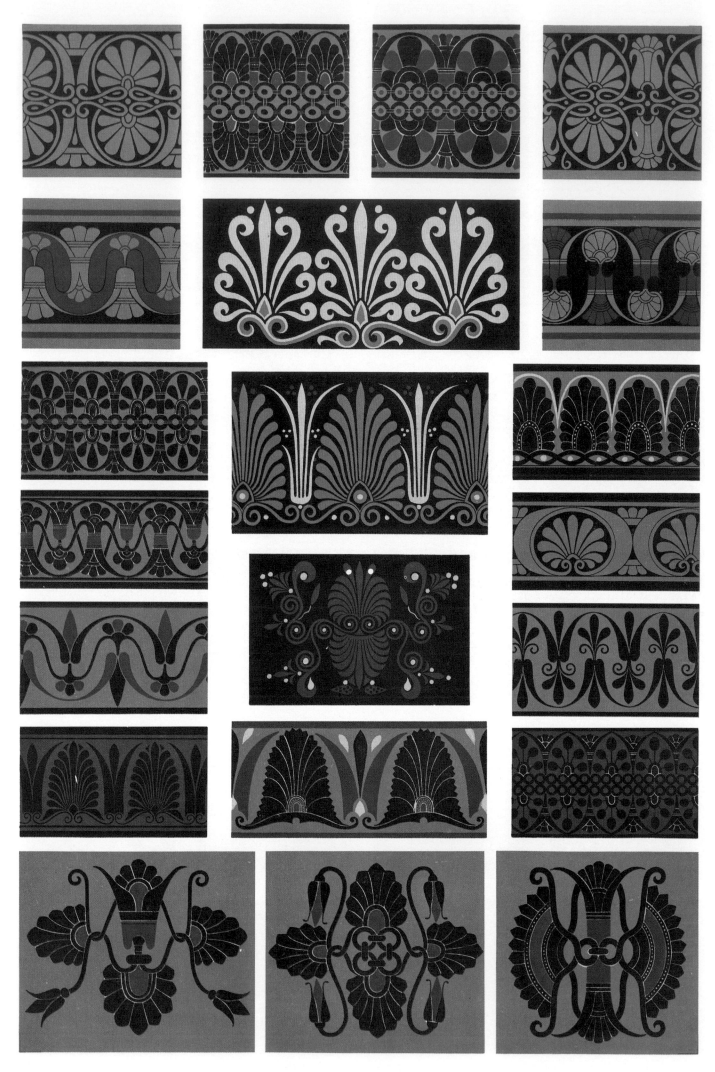

Plate XVIII. GREEK ORNAMENT.

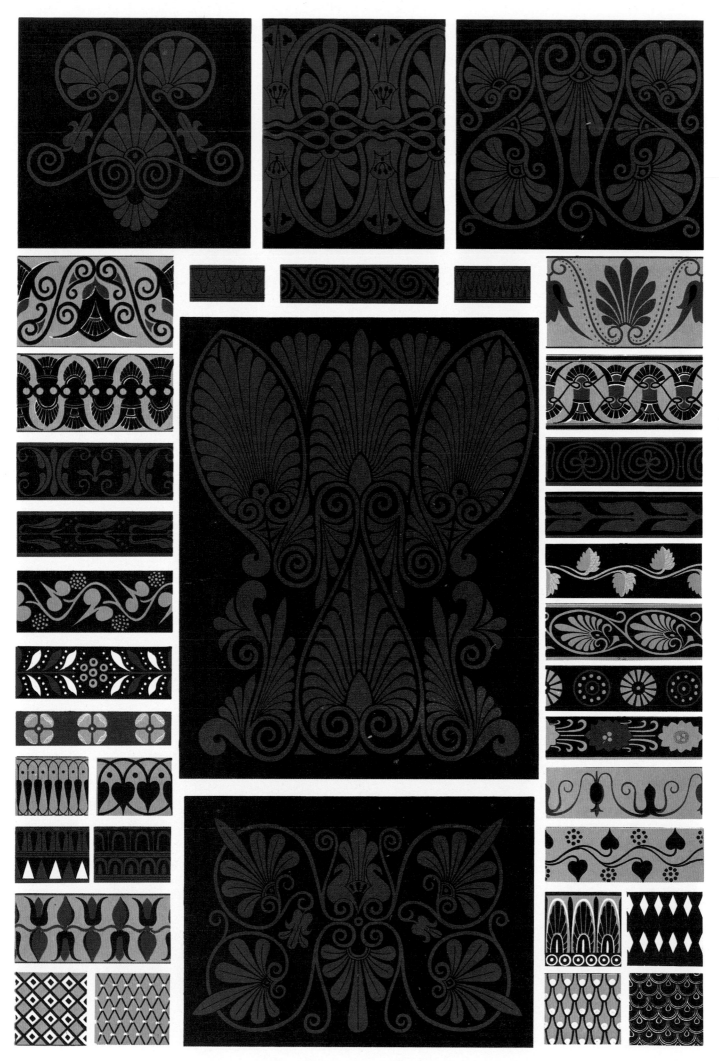

Plate XIX. GREEK ORNAMENT.

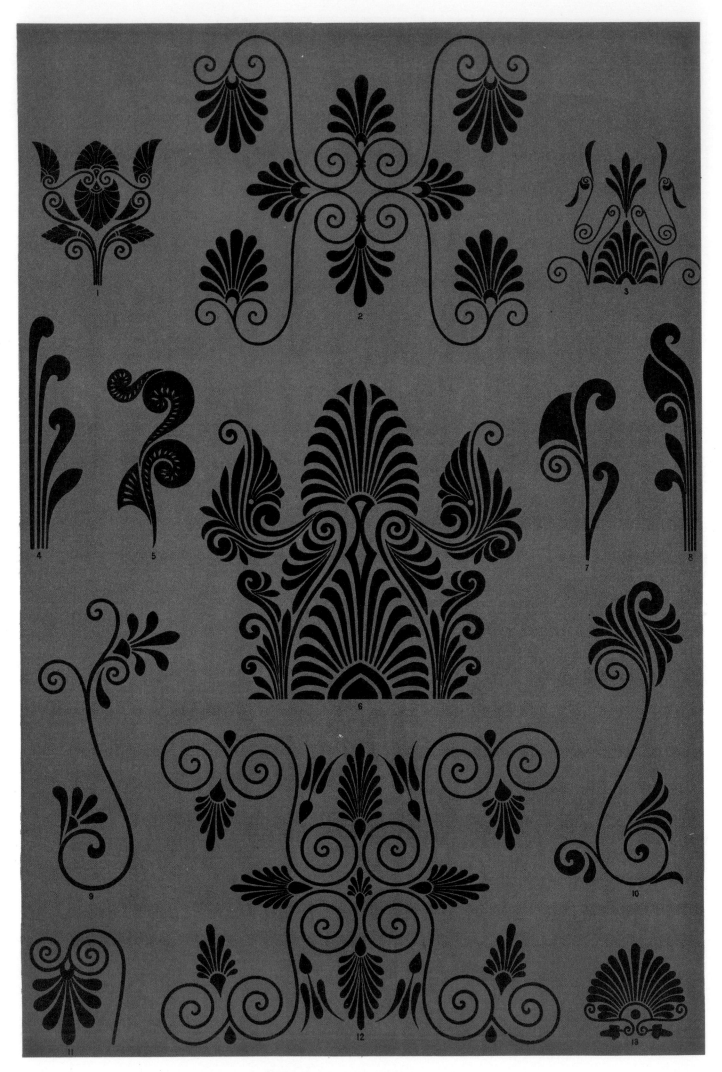

Plate XX. GREEK ORNAMENT.

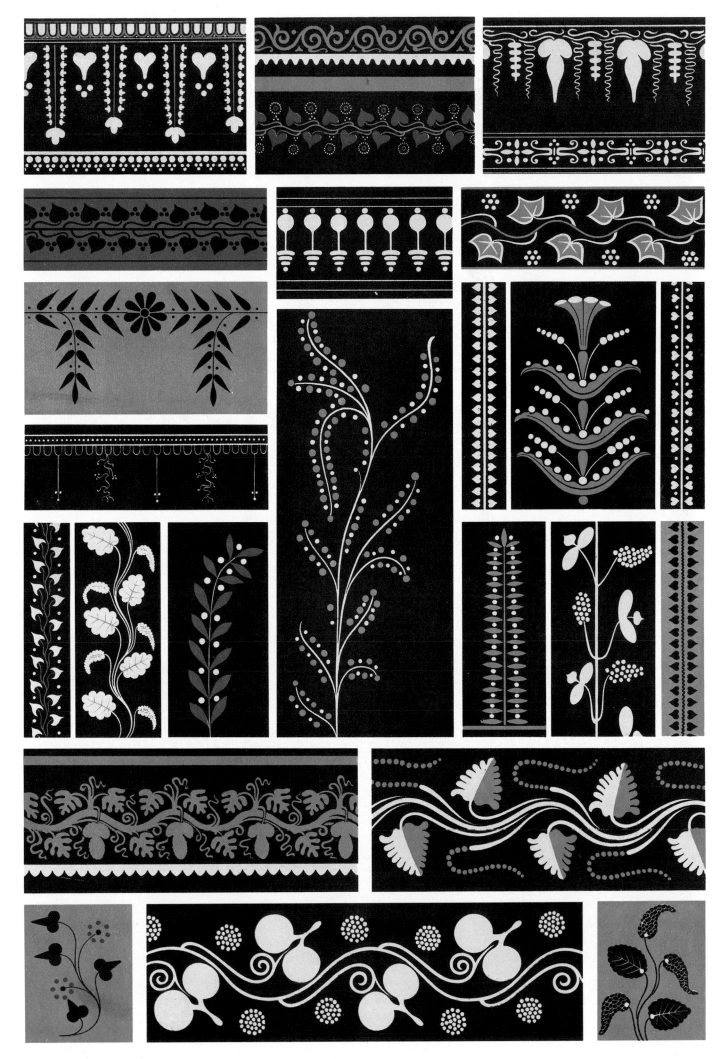

Plate XXI. GREEK ORNAMENT.

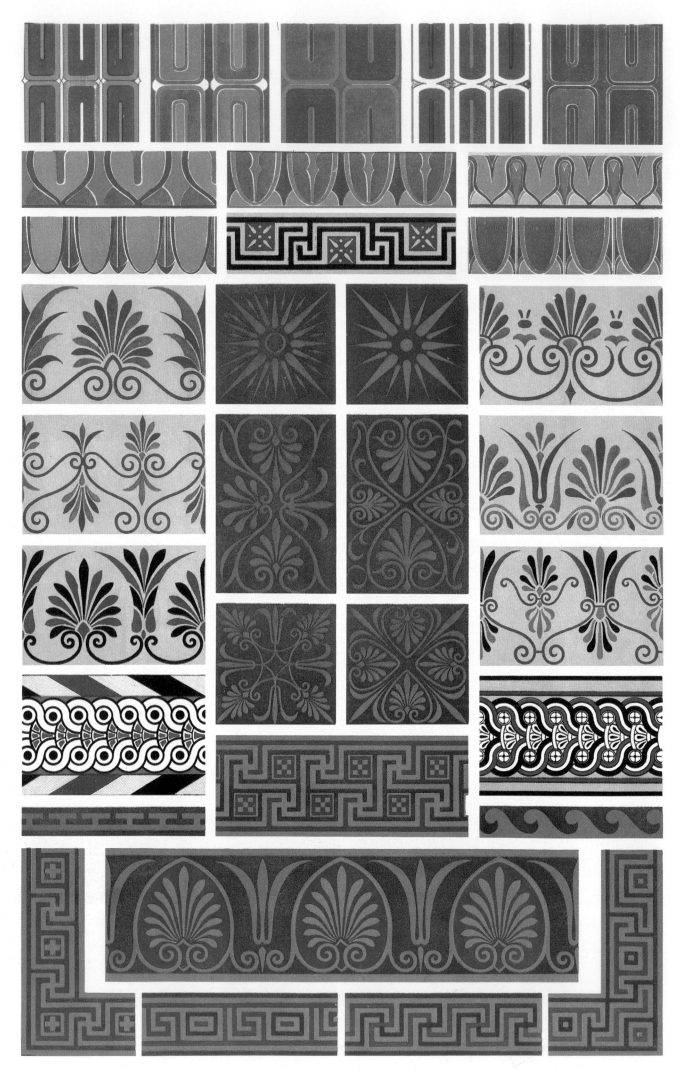

Plate XXII. GREEK ORNAMENT.

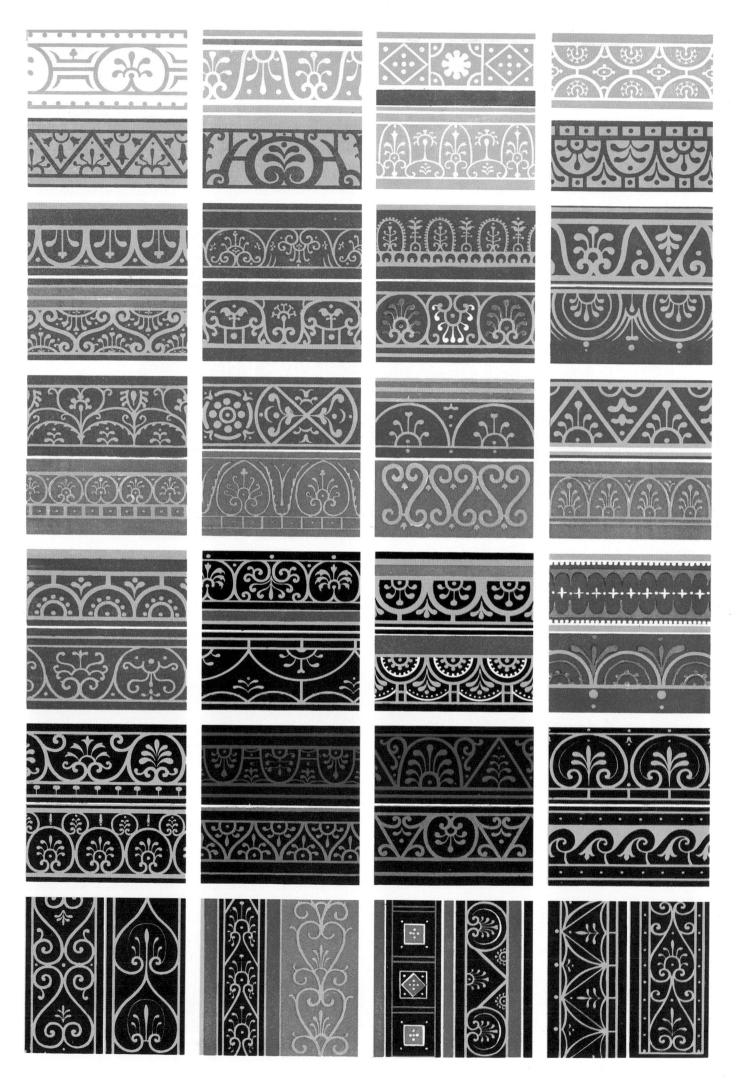

Plate XXIII. PᴏᴍPᴇɪᴀɴ Oʀɴᴀᴍᴇɴᴛ.

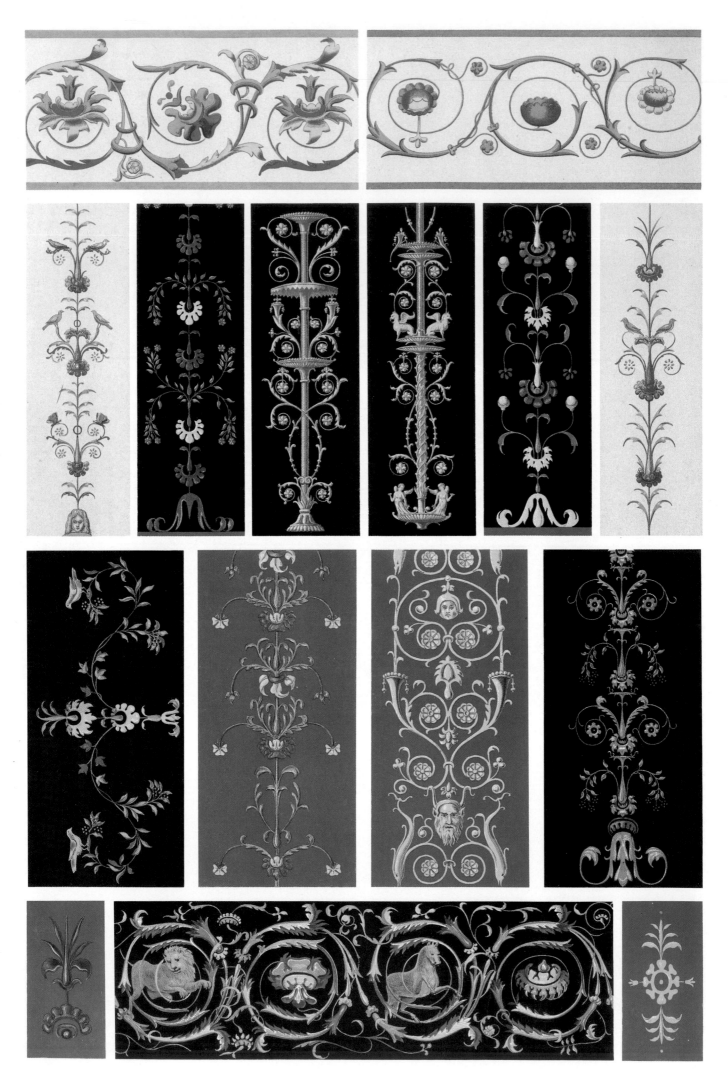

Plate XXIV. Pompeian Ornament.

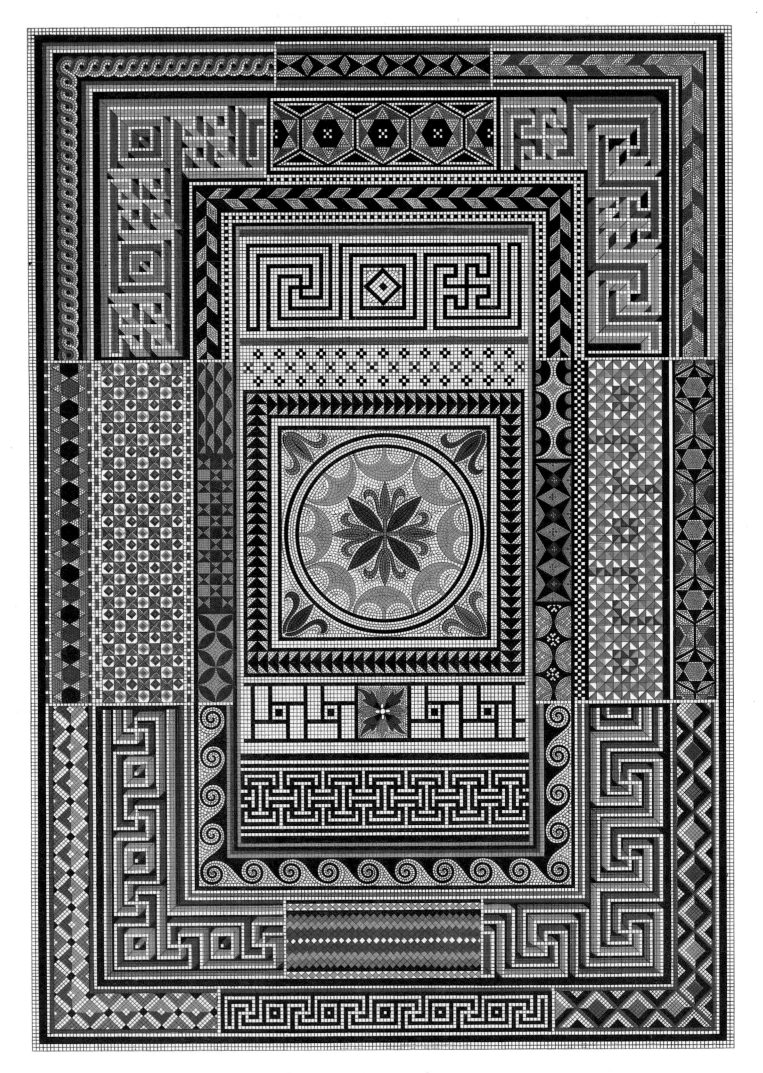

Plate XXV. POMPEIAN ORNAMENT.

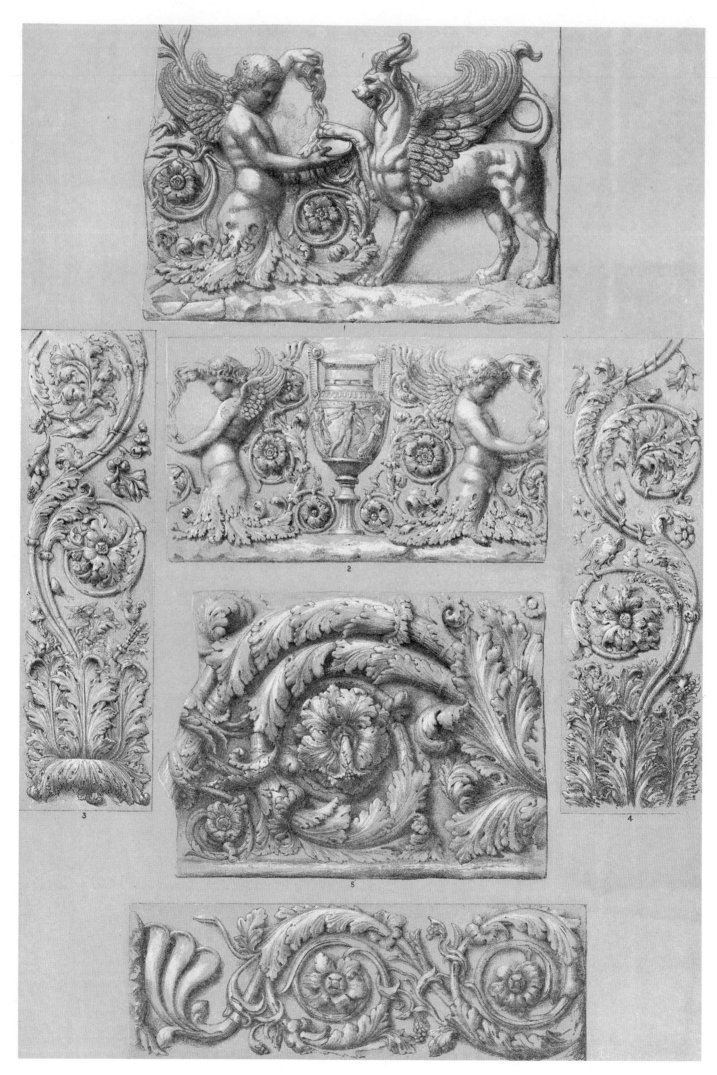

Plate XXVI. ROMAN ORNAMENT.

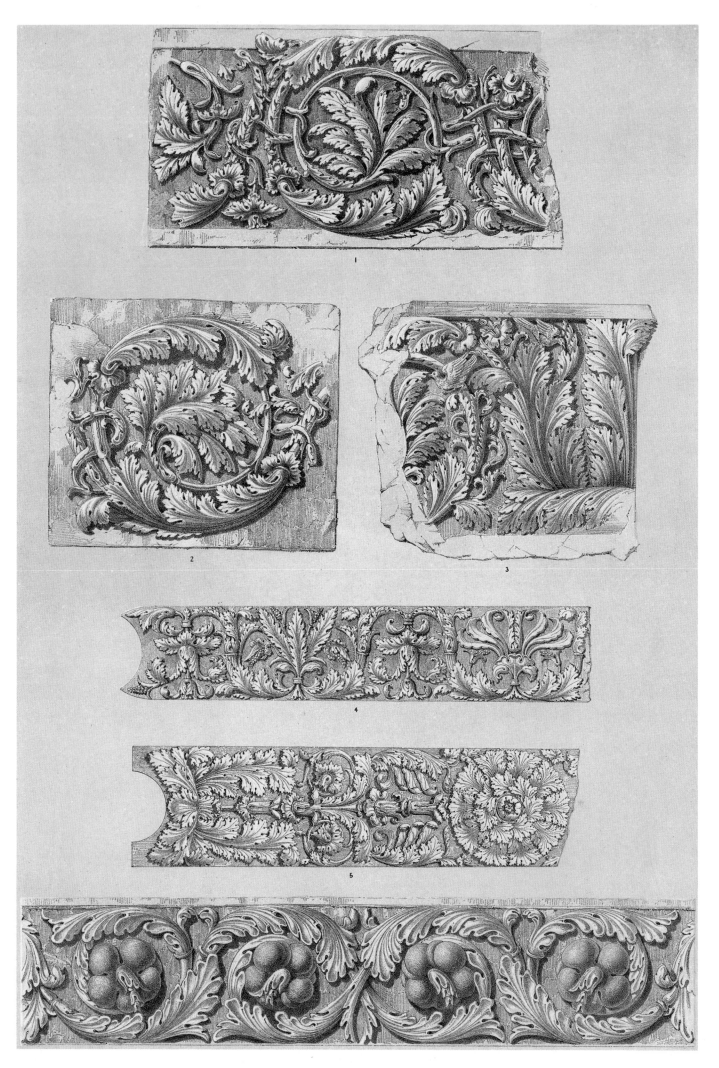

Plate XXVII. ROMAN ORNAMENT.

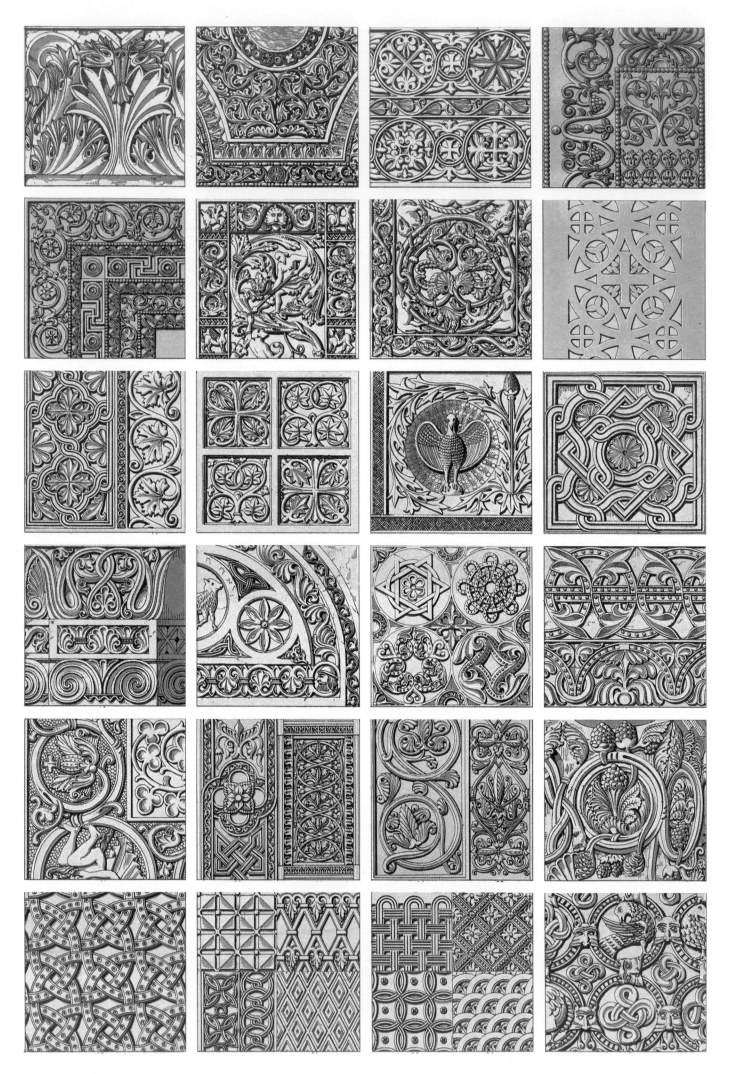

Plate XXVIII. BYZANTINE ORNAMENT.

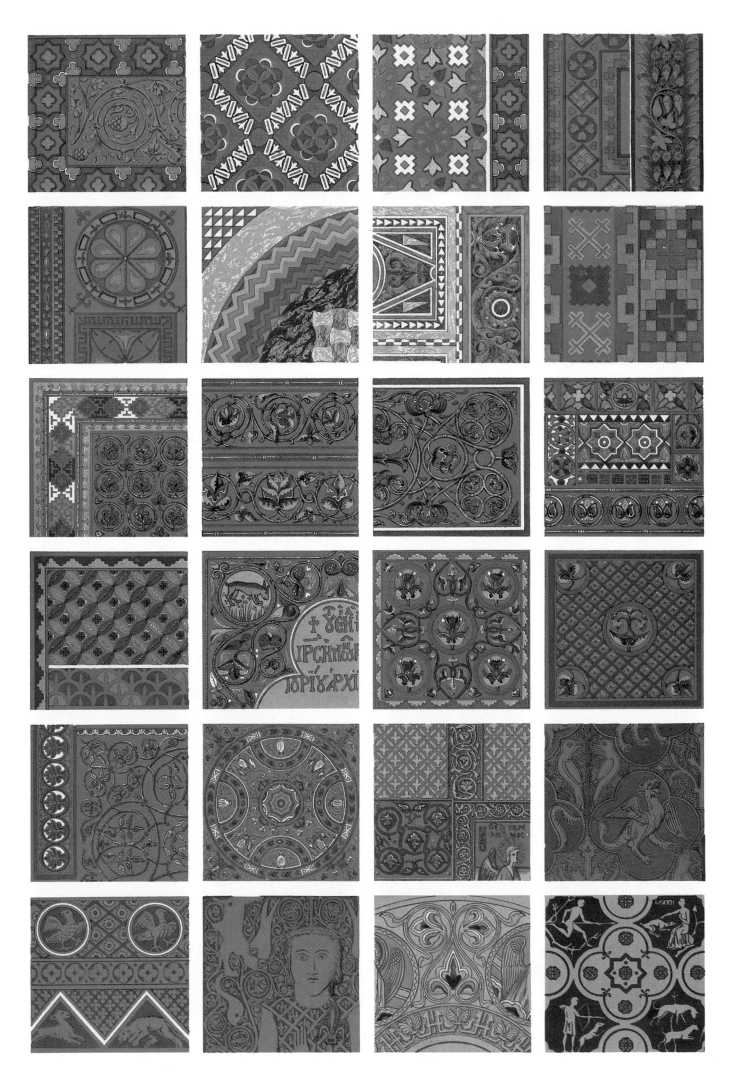

Plate XXIX. BYZANTINE ORNAMENT.

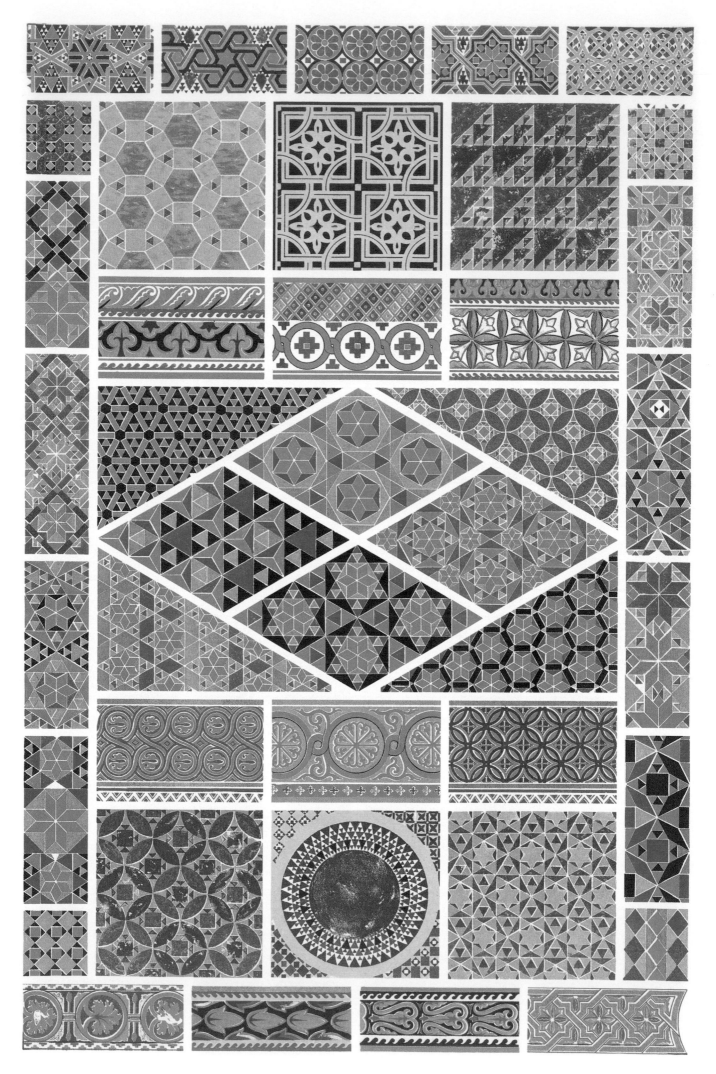

Plate XXX. Byzantine Ornament.

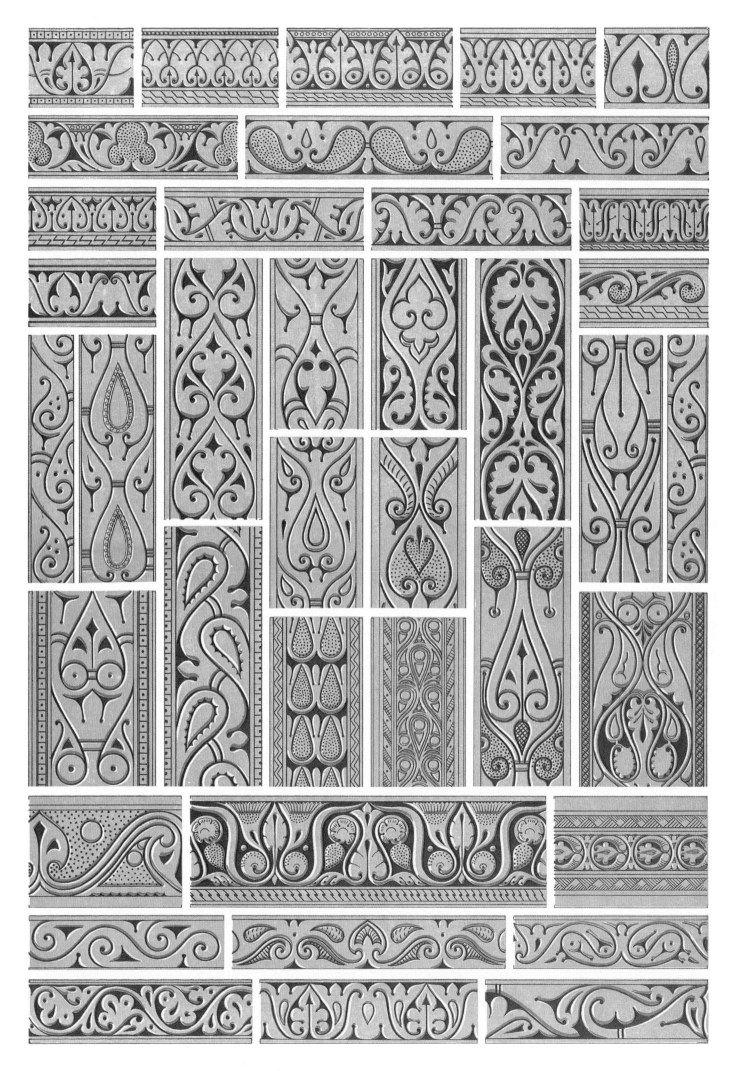

Plate XXXI. Arabian Ornament.

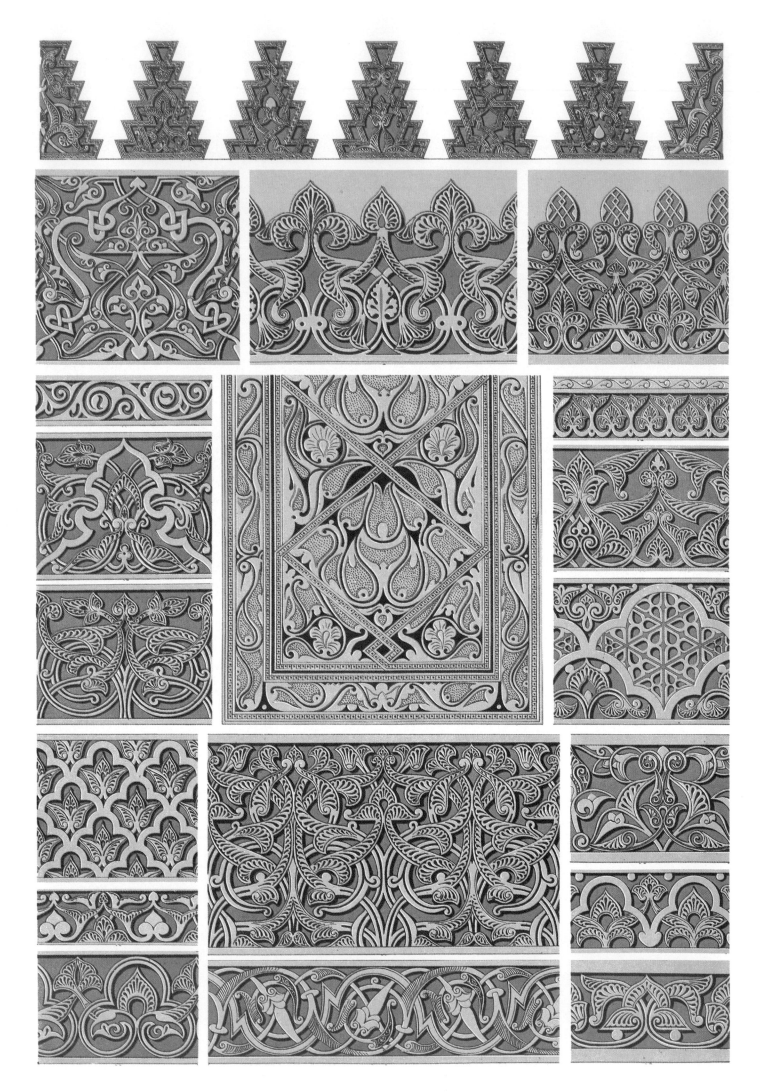

Plate XXXII. ARABIAN ORNAMENT.

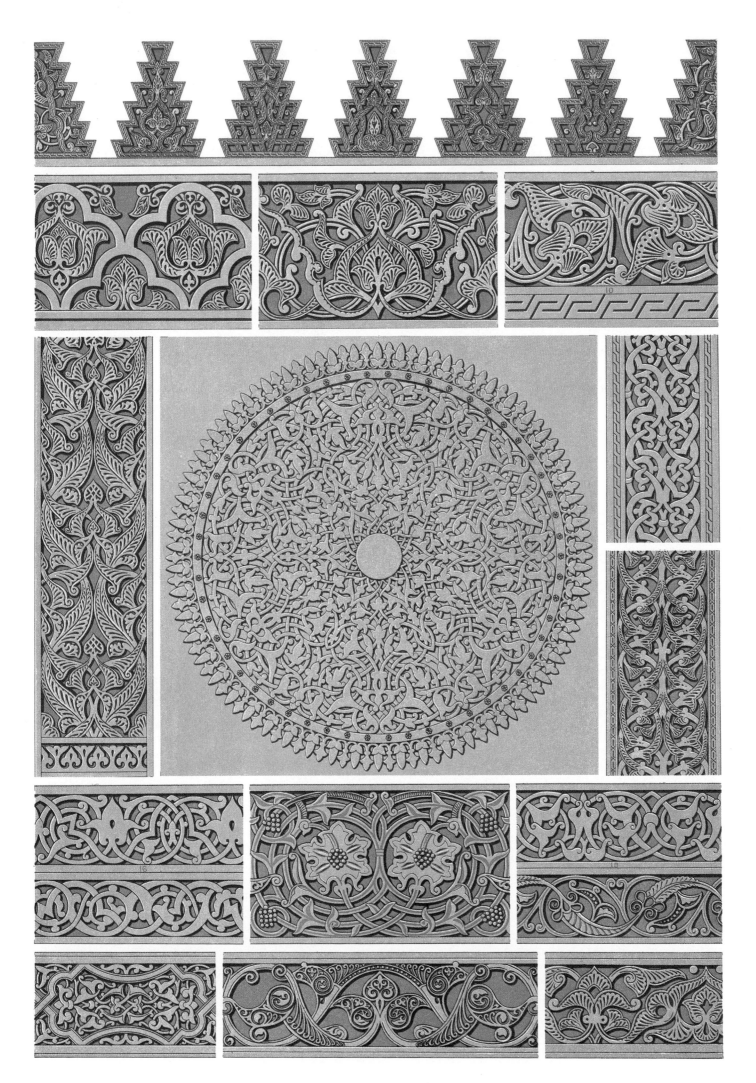

Plate XXXIII. ARABIAN ORNAMENT.

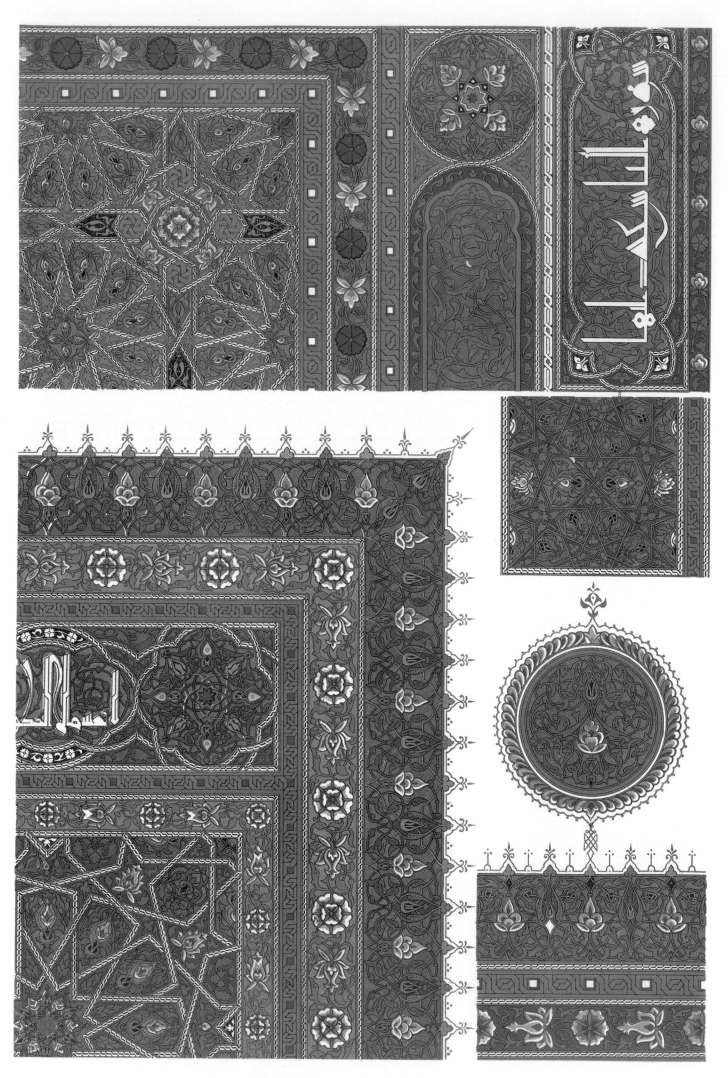

Plate XXXIV. ARABIAN ORNAMENT.

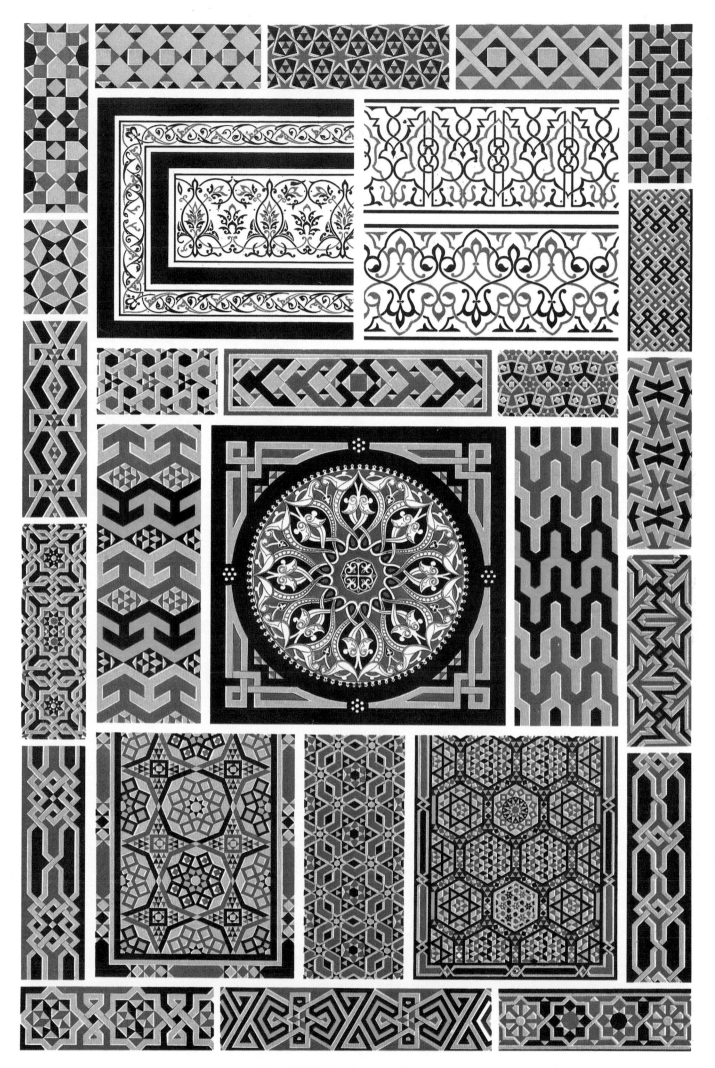

Plate XXXV. ARABIAN ORNAMENT.

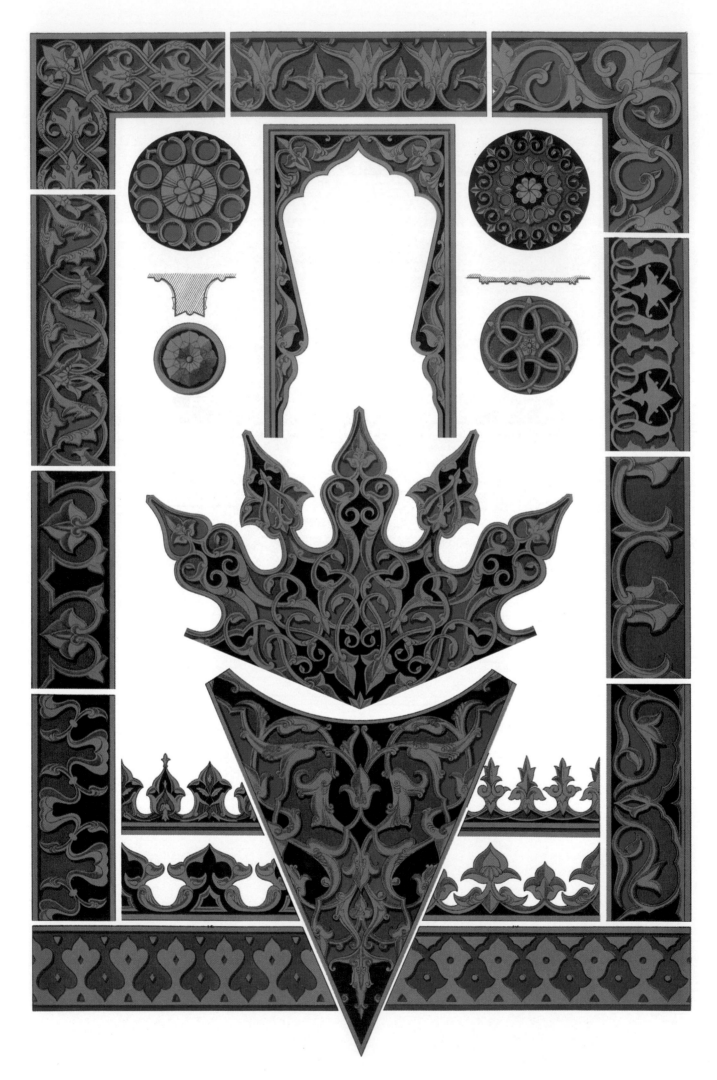

Plate XXXVI. Turkish Ornament.

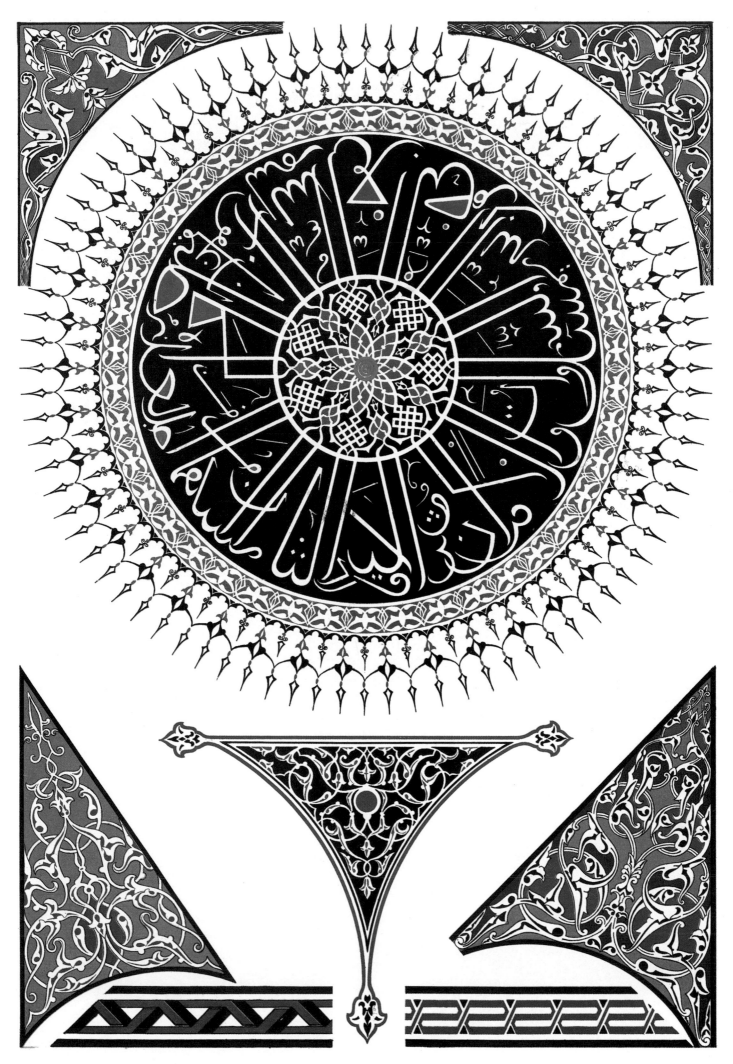

Plate XXXVII. Turkish Ornament.

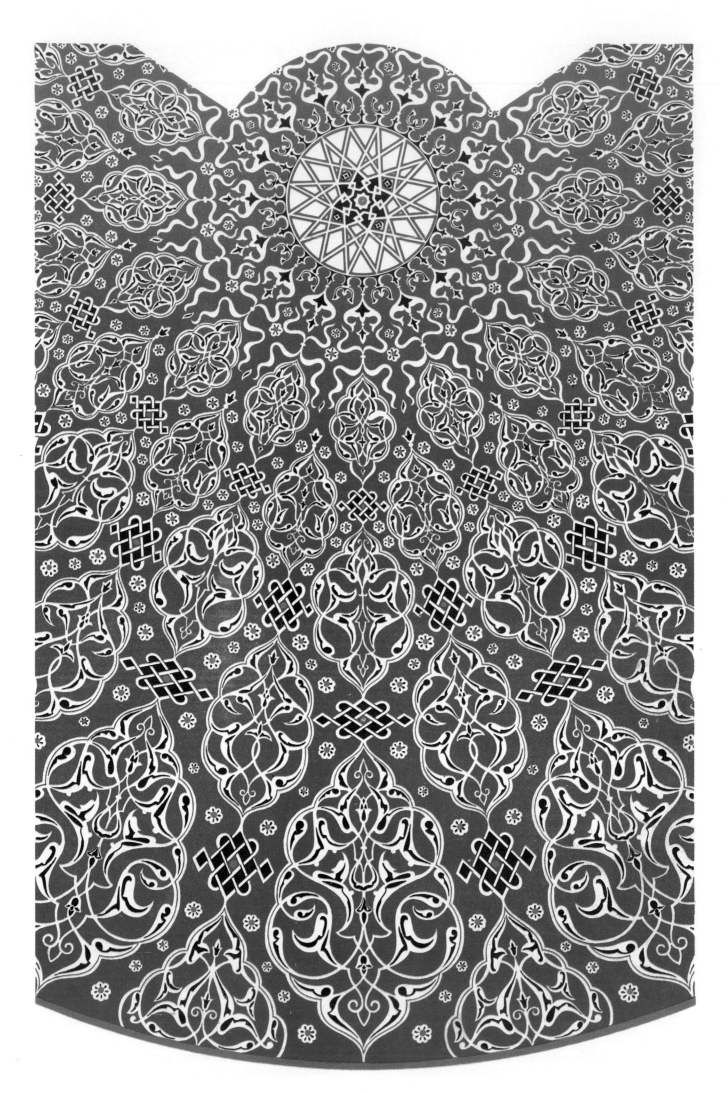

Plate XXXVIII. TURKISH ORNAMENT.

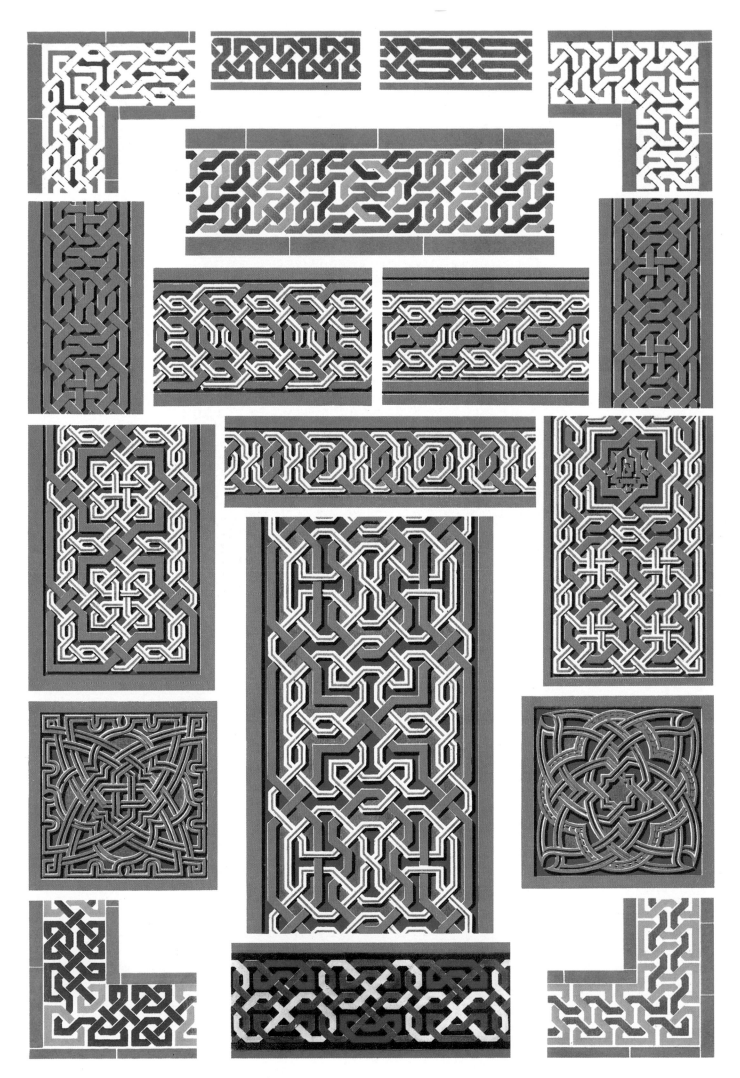

Plate XXXIX. MOORISH ORNAMENT.

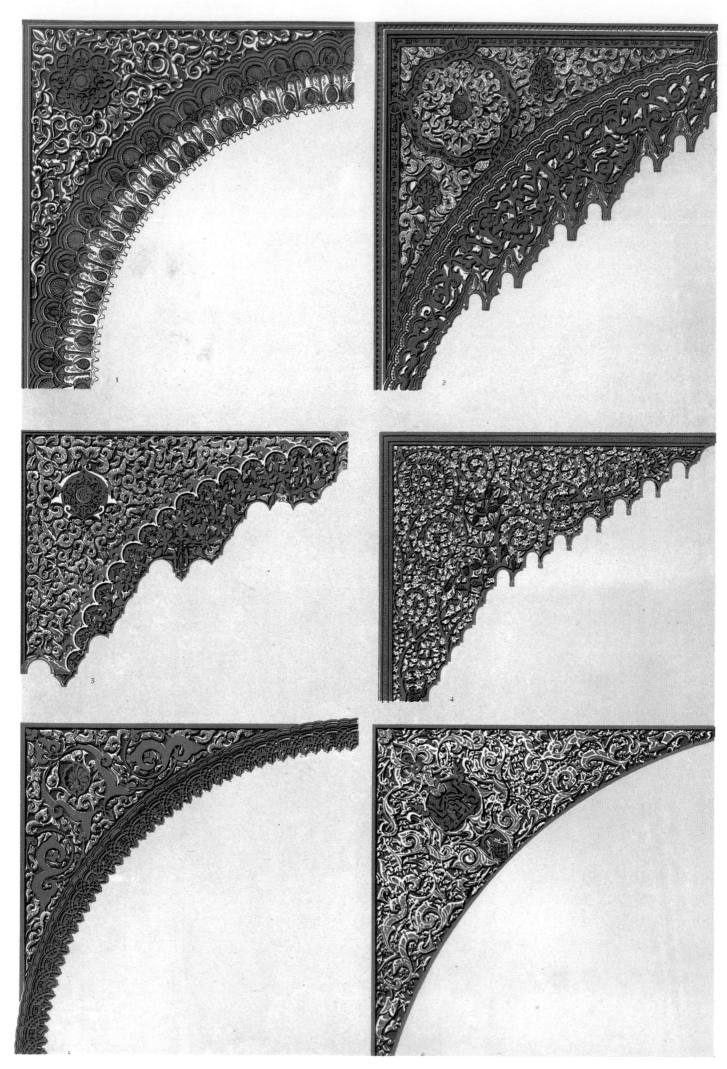

Plate XL. MOORISH ORNAMENT.

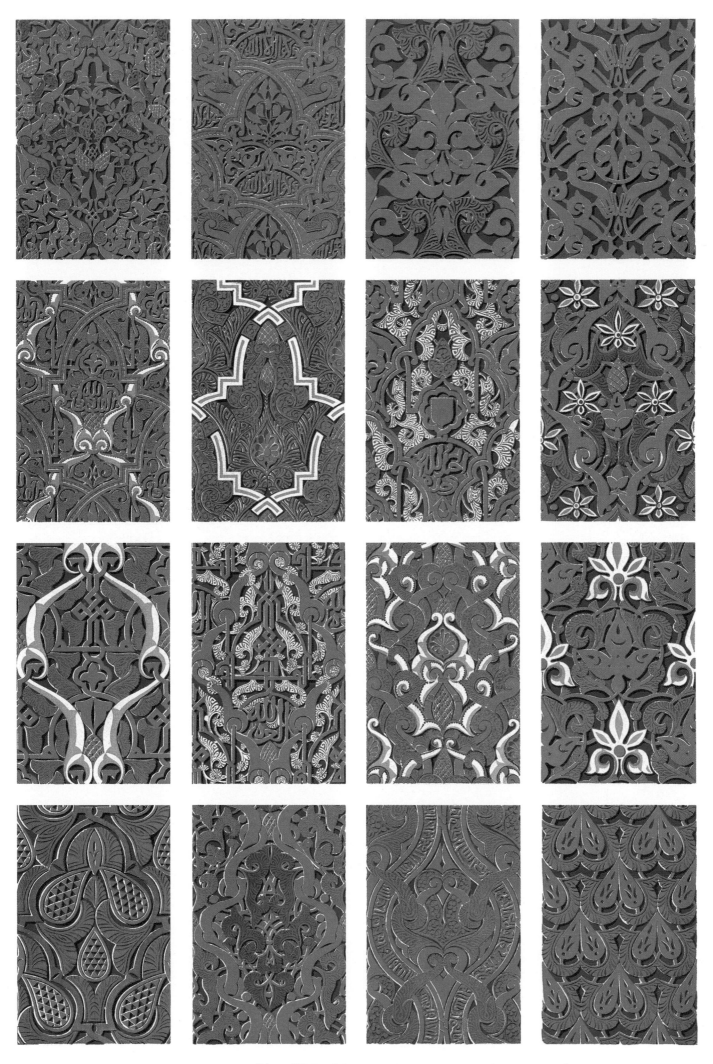

Plate XLI. MOORISH ORNAMENT.

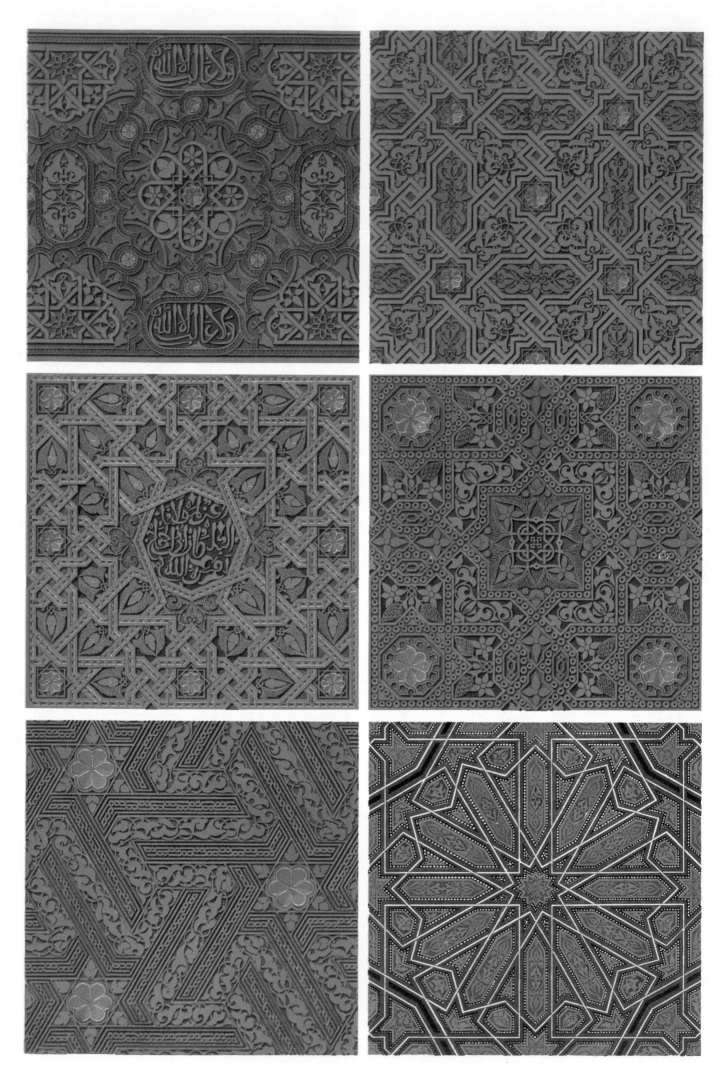

Plate XLII. Moorish Ornament.

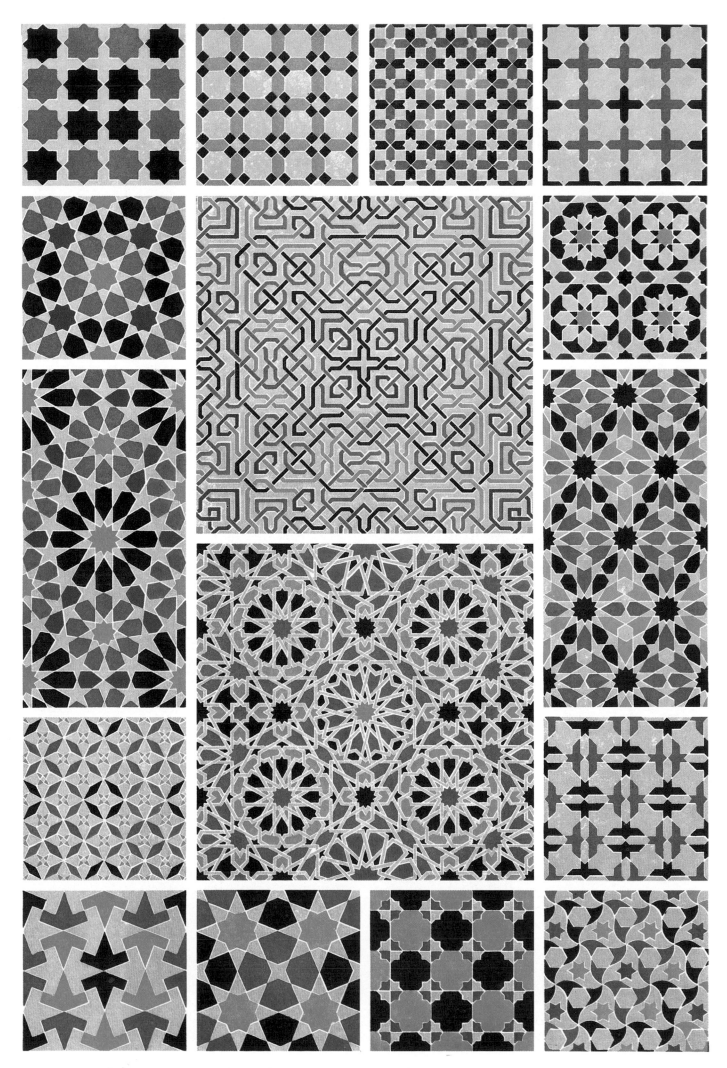

Plate XLIII. Moorish Ornament.

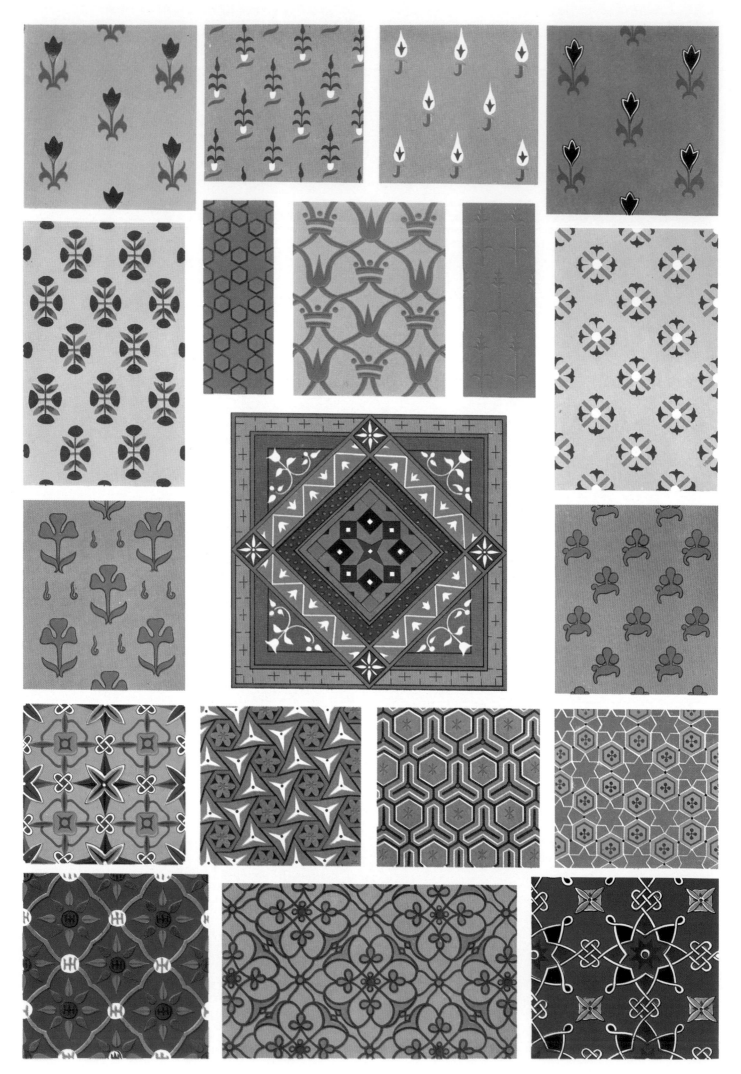

Plate XLIV. PERSIAN ORNAMENT.

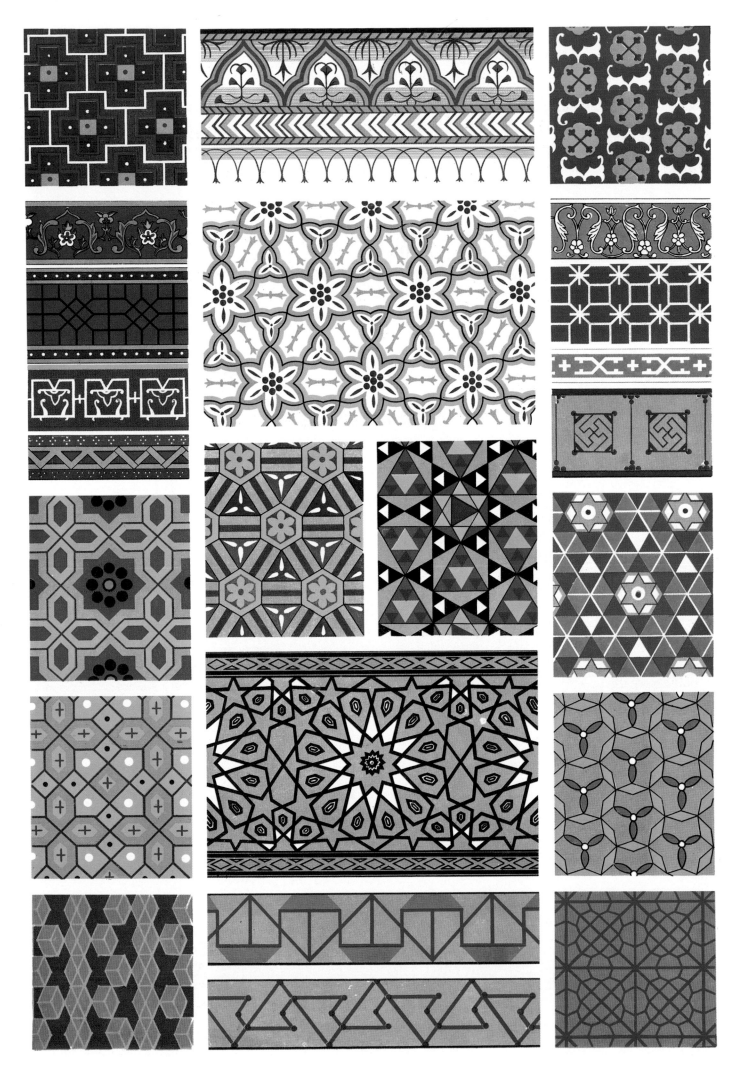

Plate XLV. PERSIAN ORNAMENT.

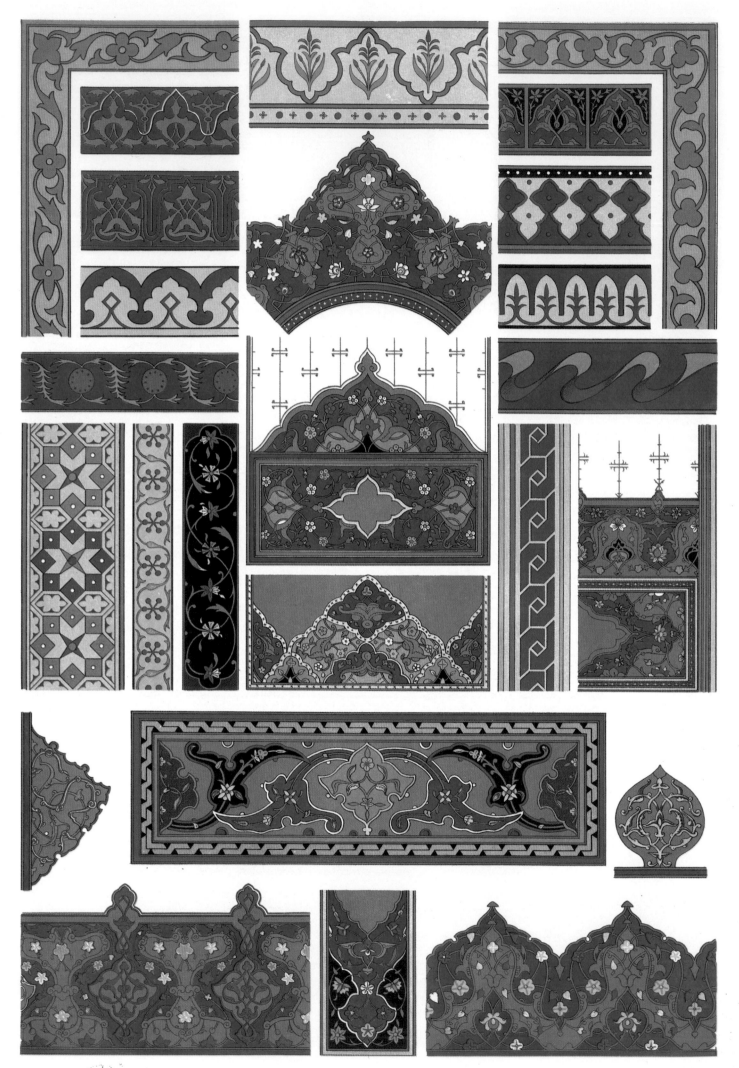

Plate XLVI. PERSIAN ORNAMENT.

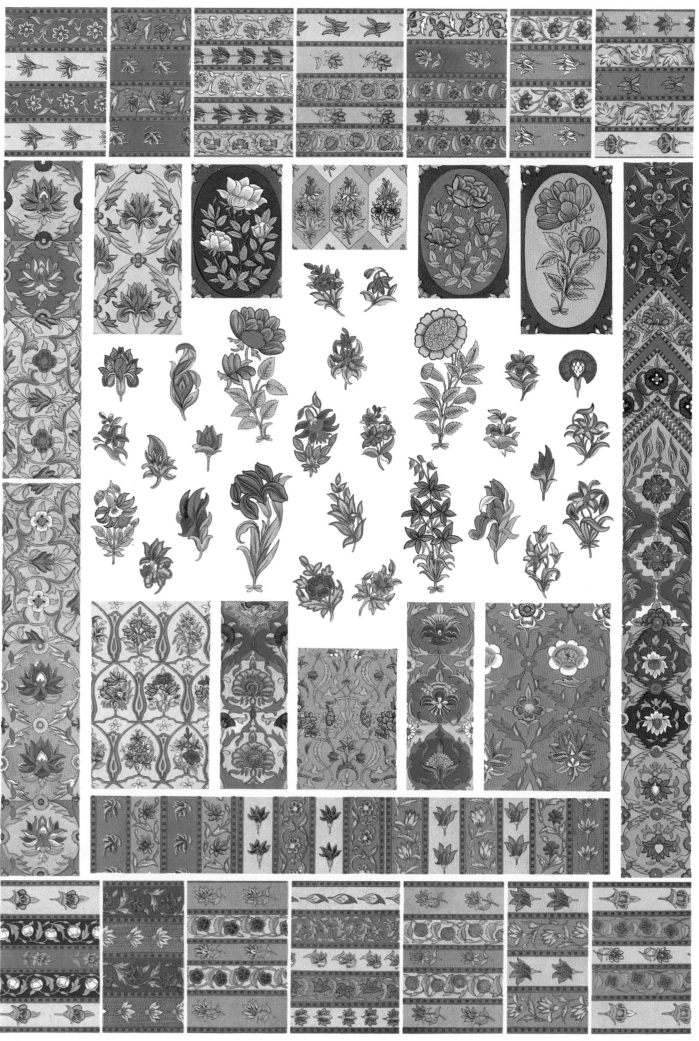

Plate XLVII. Persian Ornament.

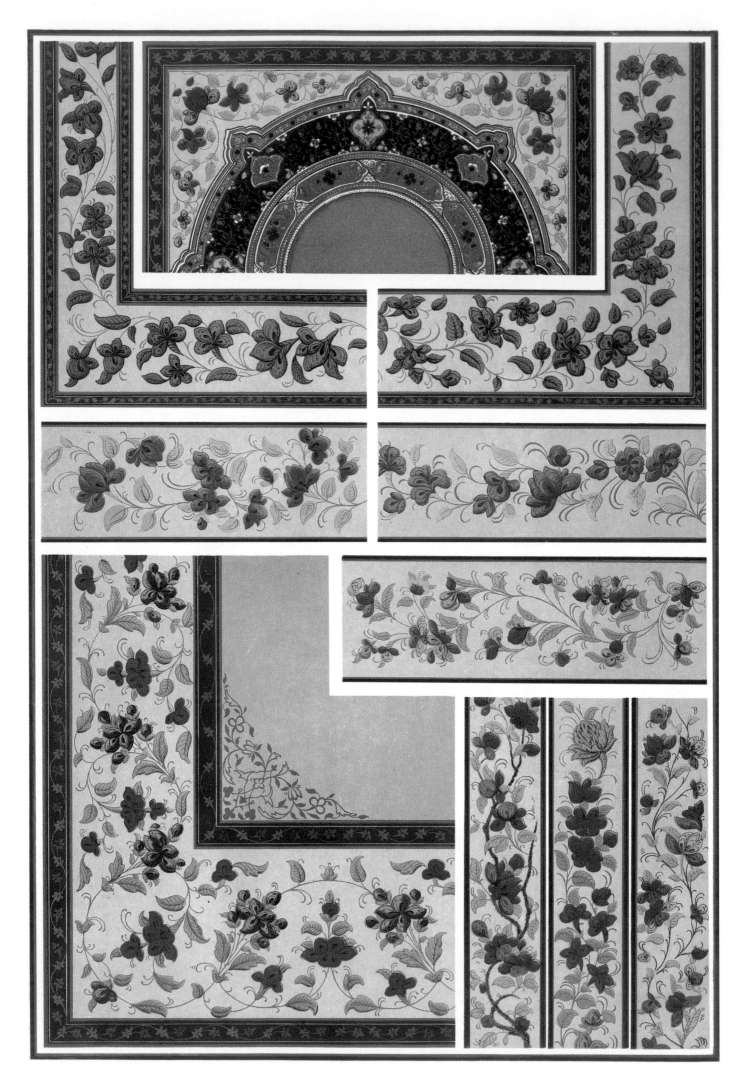

Plate XLVIII. PERSIAN ORNAMENT.

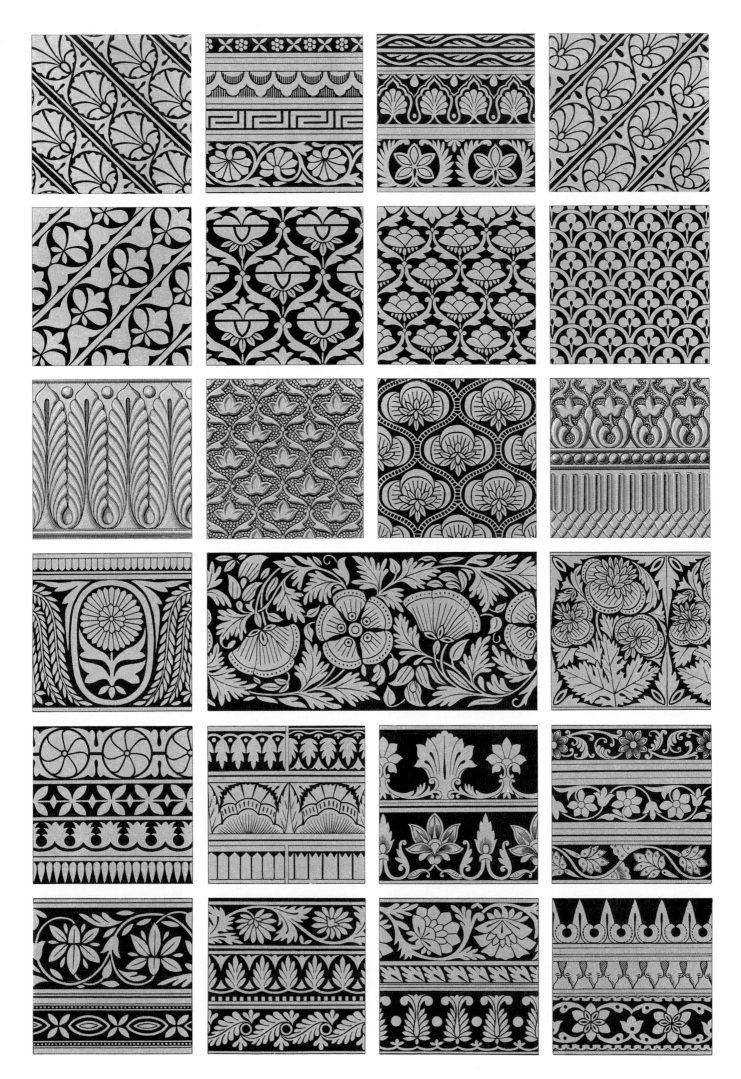

Plate XLIX. Indian Ornament.

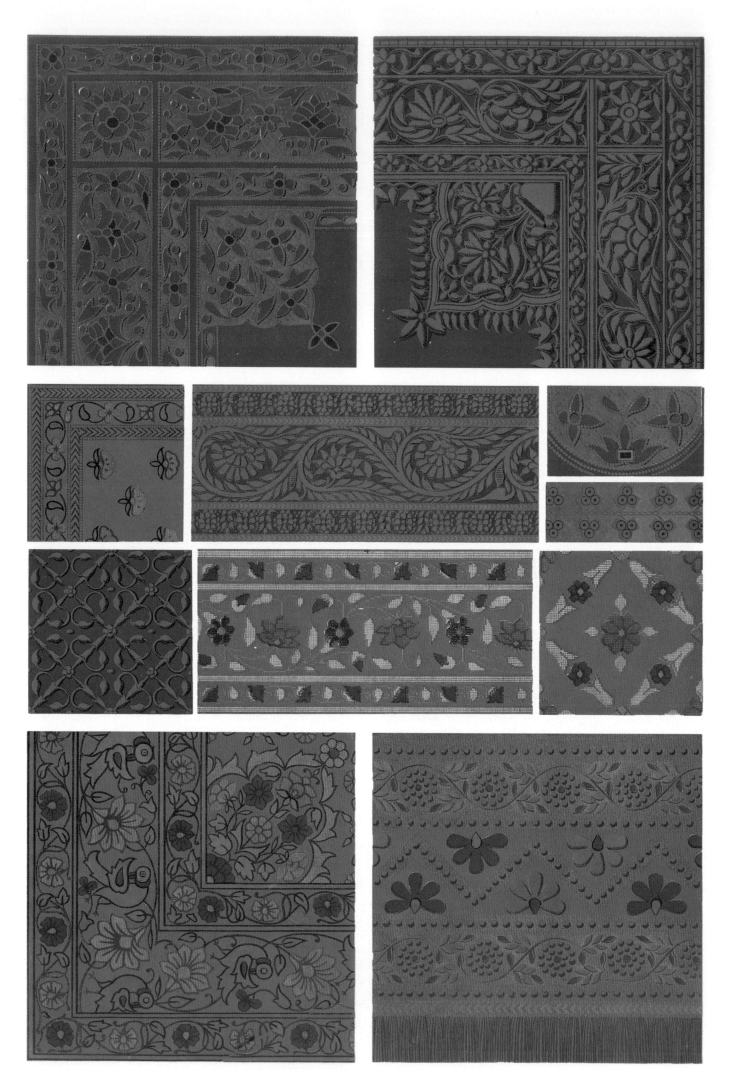

Plate L. Indian Ornament.

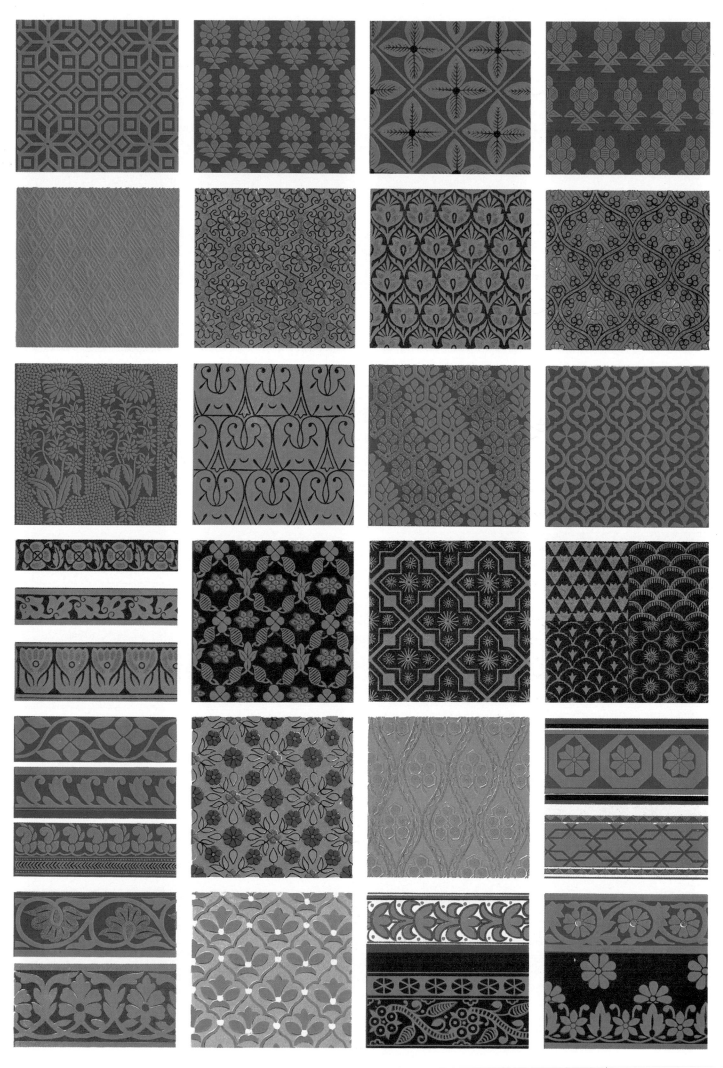

Plate LI. INDIAN ORNAMENT.

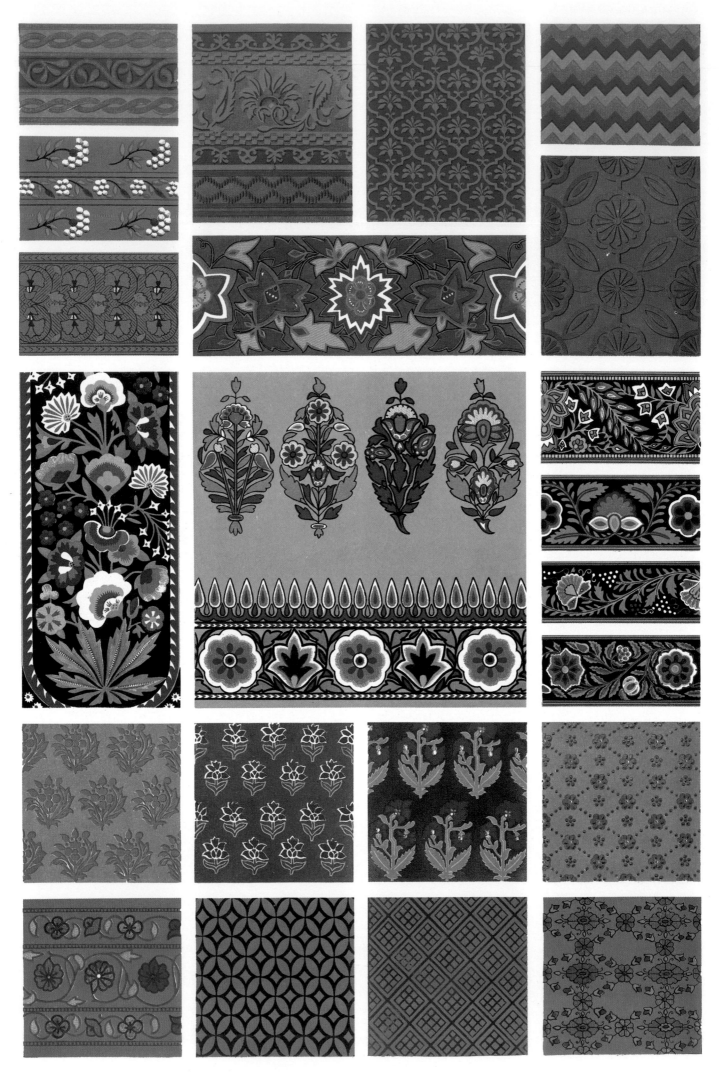

Plate LII. INDIAN ORNAMENT.

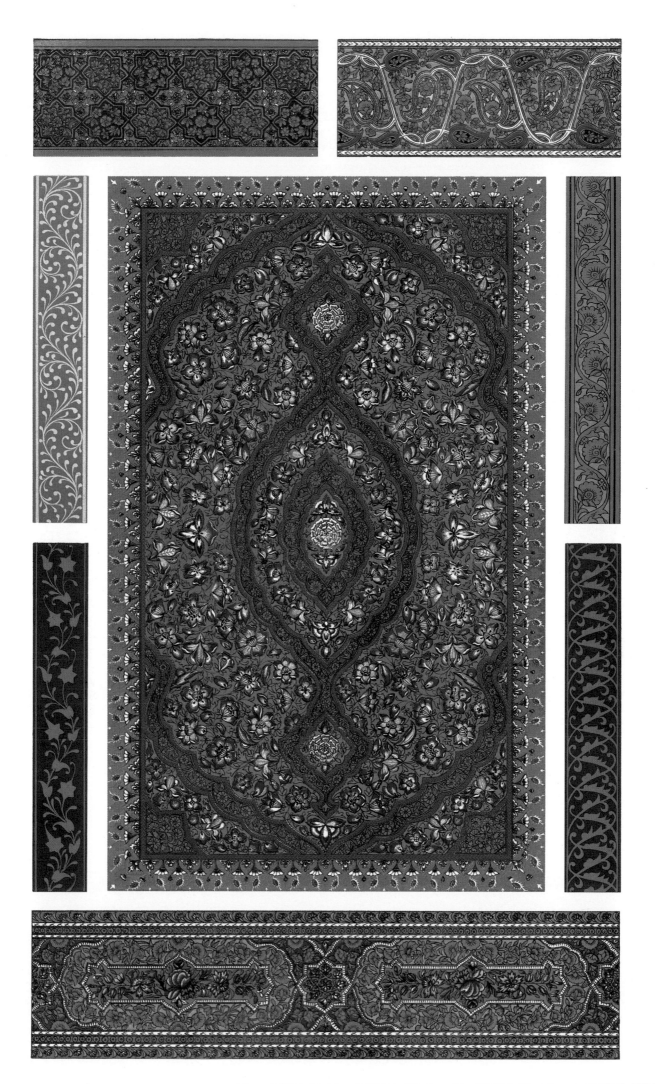

Plate LIII. Indian Ornament.

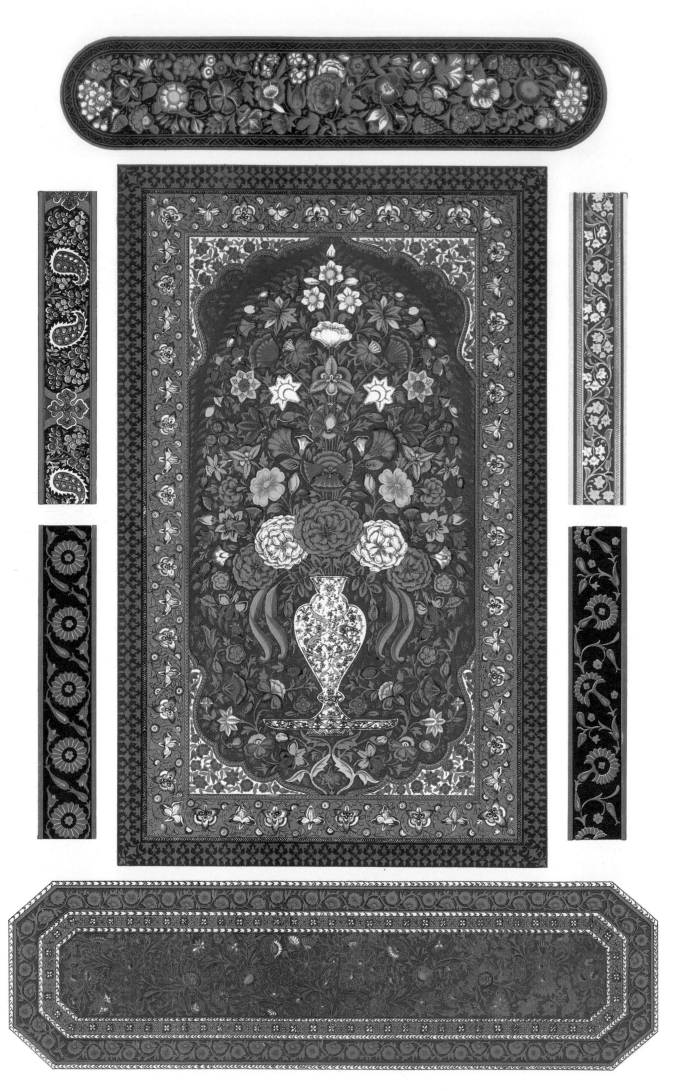

Plate LIV. INDIAN ORNAMENT.

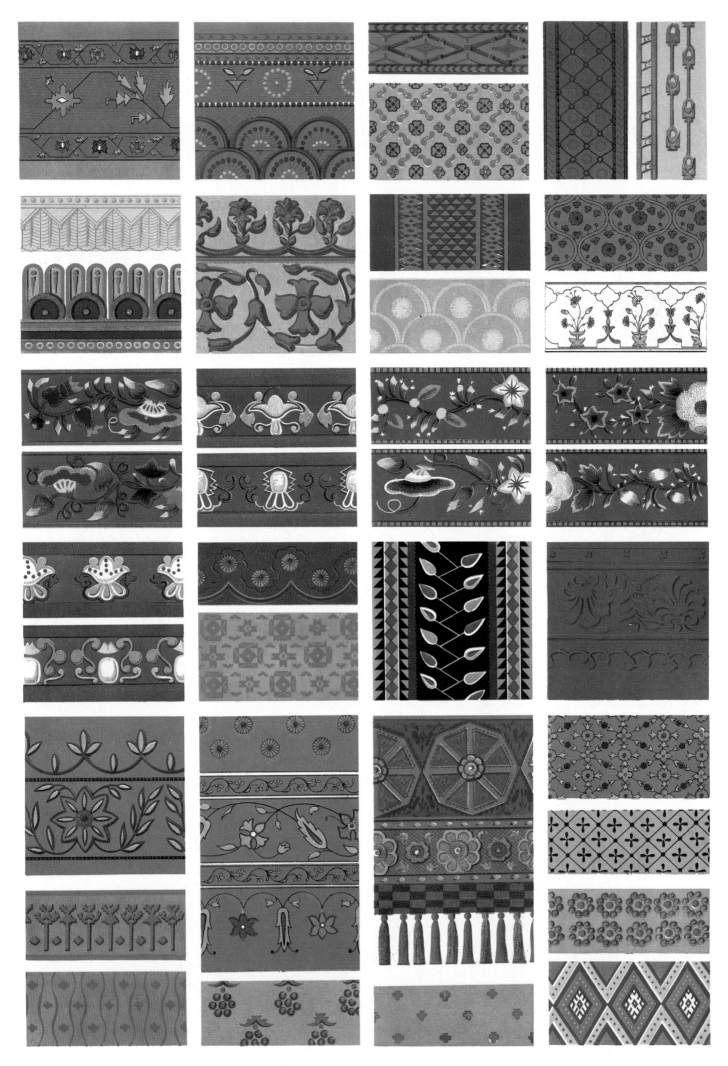

Plate LV. INDIAN ORNAMENT.

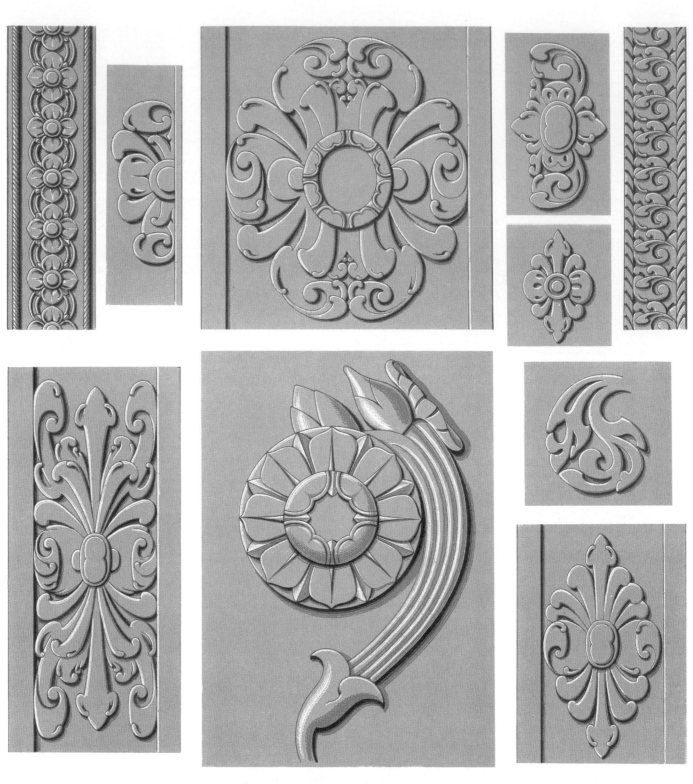

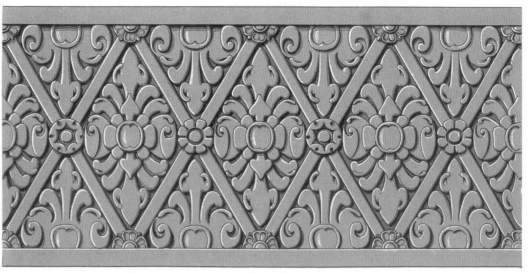

Plate LVI. Indian and Burmese Ornament.

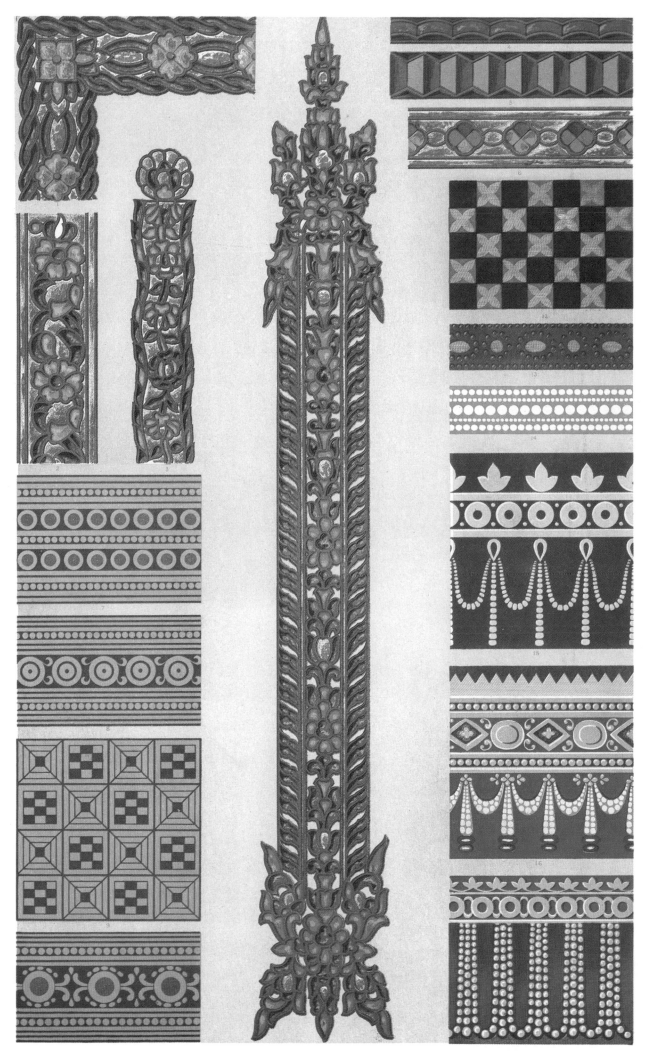

Plate LVII. INDIAN AND BURMESE ORNAMENT.

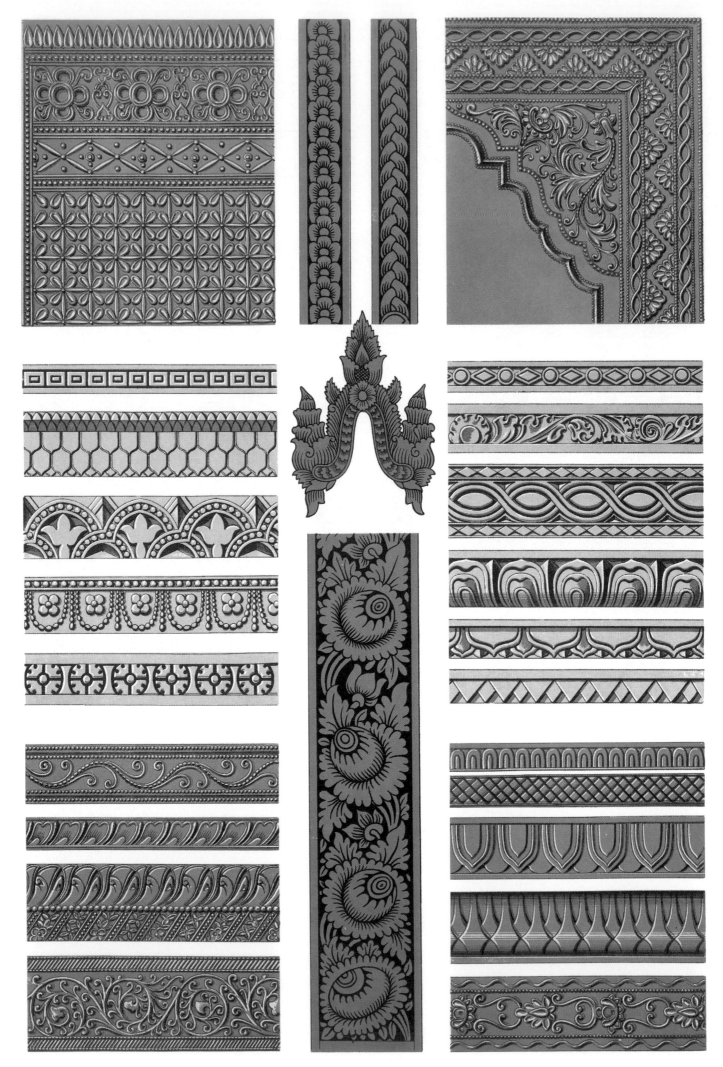

Plate LVIII. INDIAN AND BURMESE ORNAMENT.

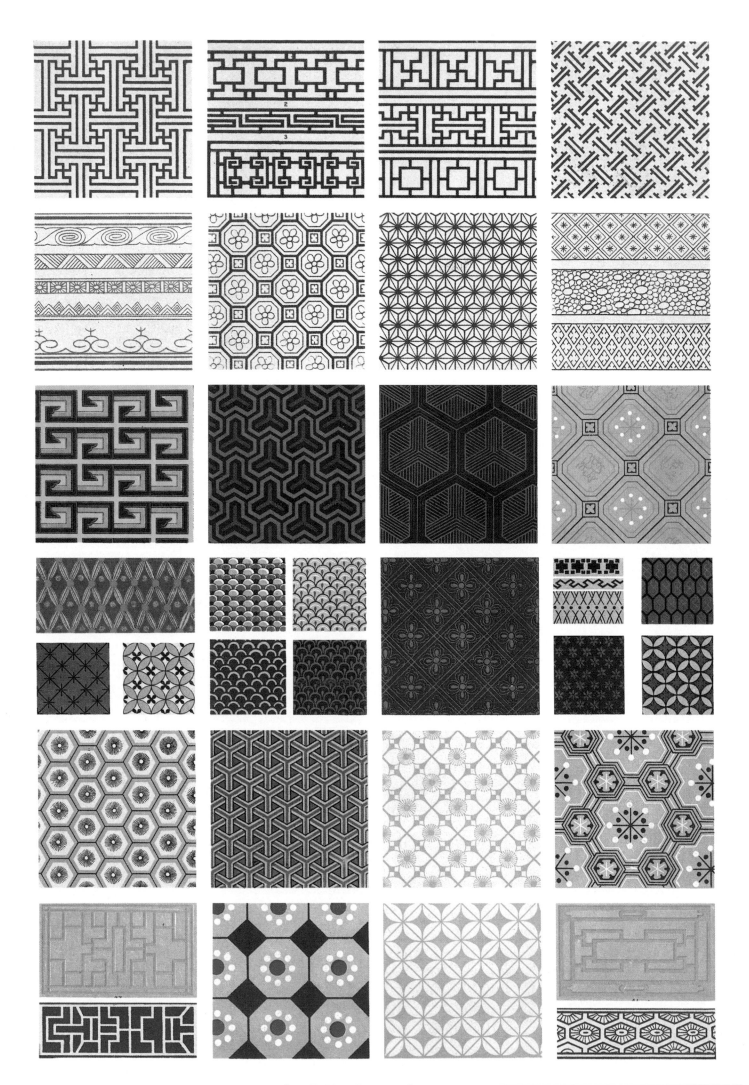

Plate LIX. CHINESE ORNAMENT.

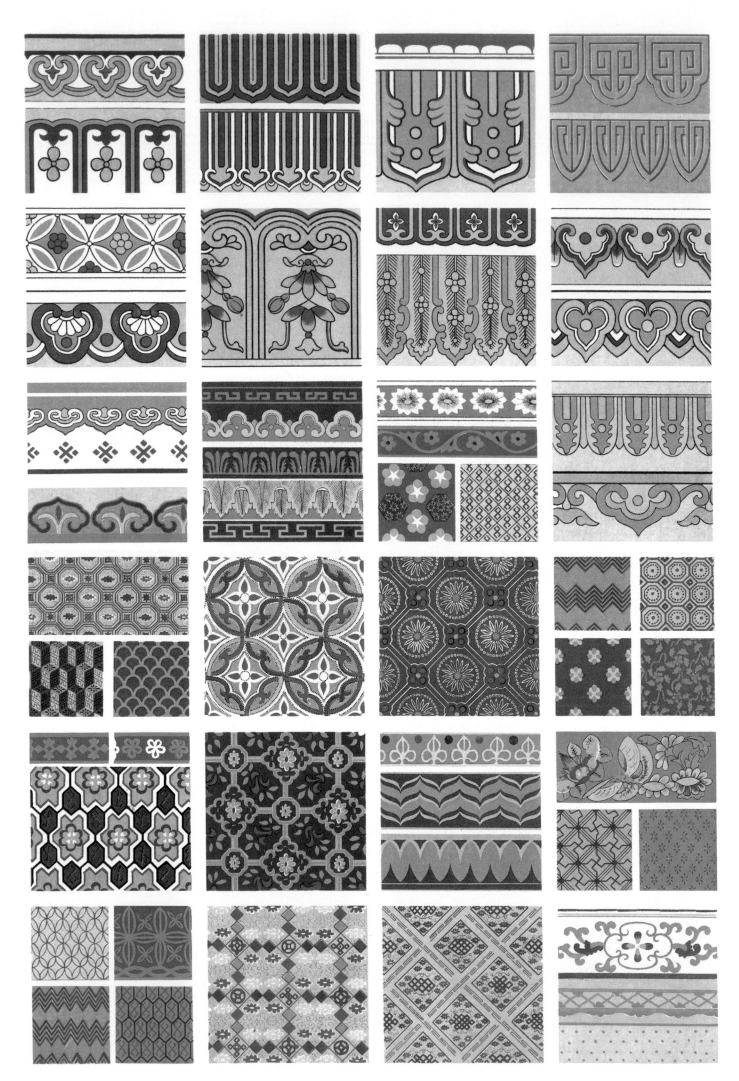

Plate LX. Chinese Ornament.

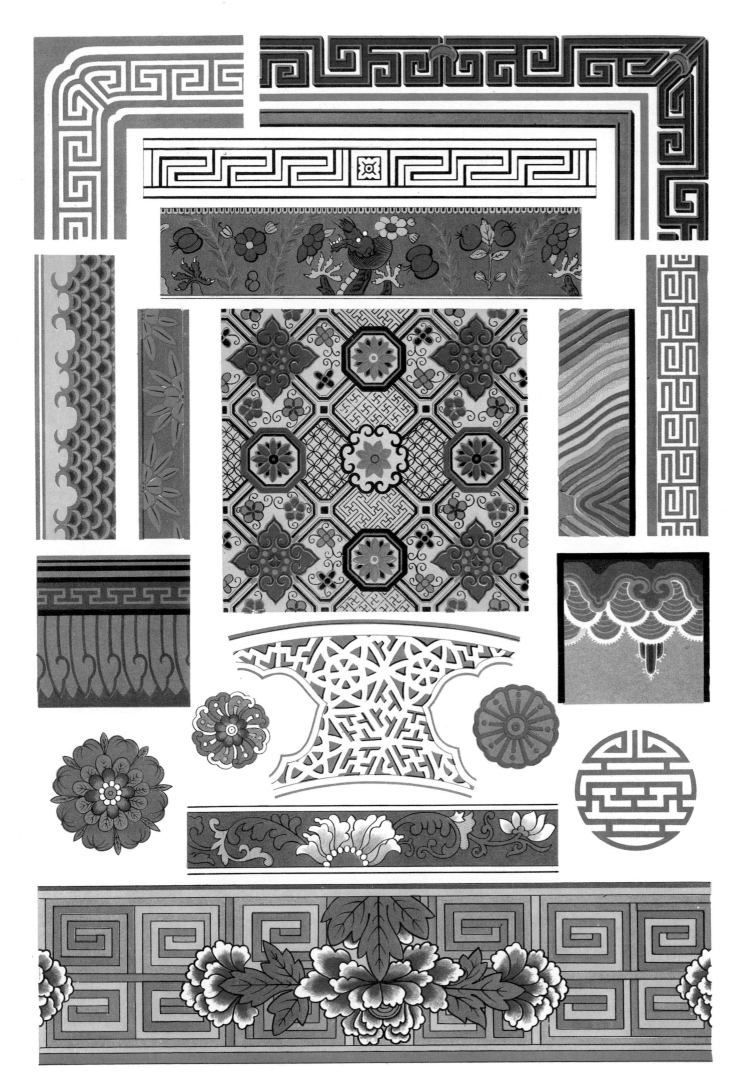

Plate LXI. CHINESE ORNAMENT.

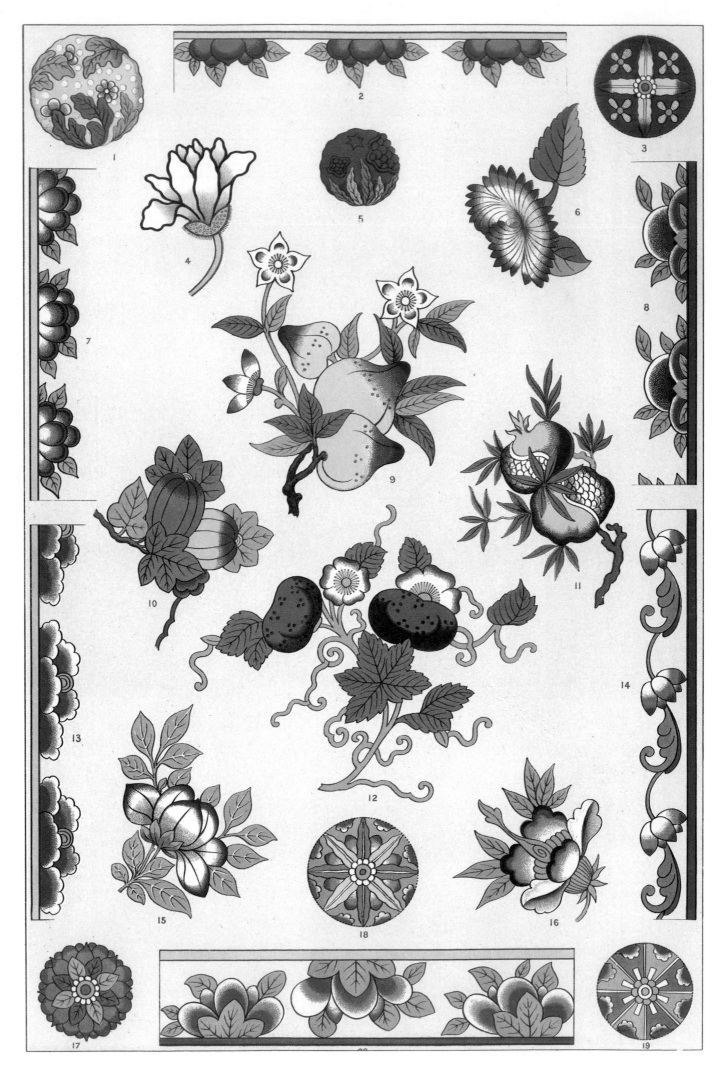

Plate LXII. Chinese Ornament.

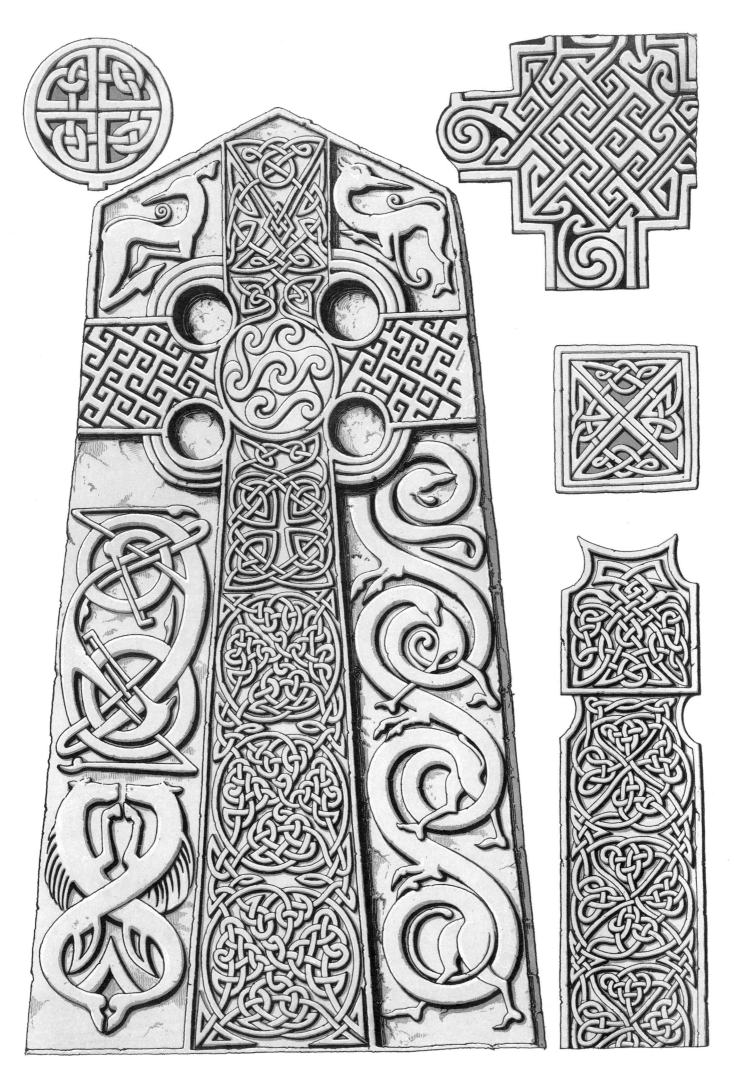

Plate LXIII. CELTIC ORNAMENT.

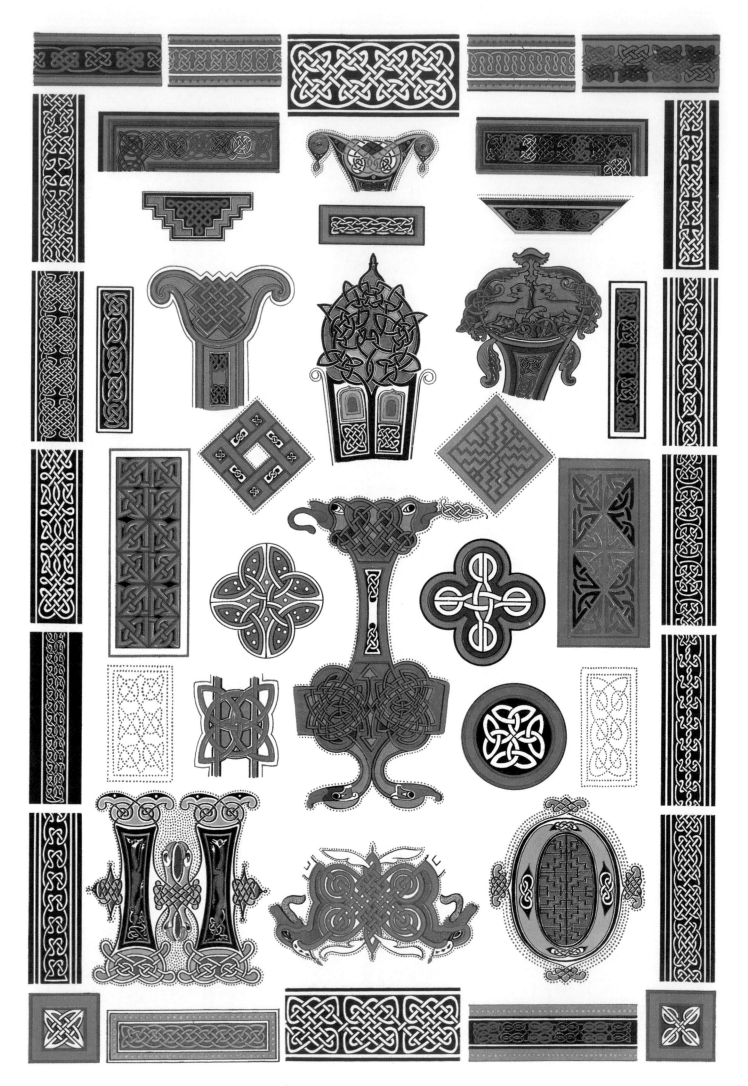

Plate LXIV. Celtic Ornament.

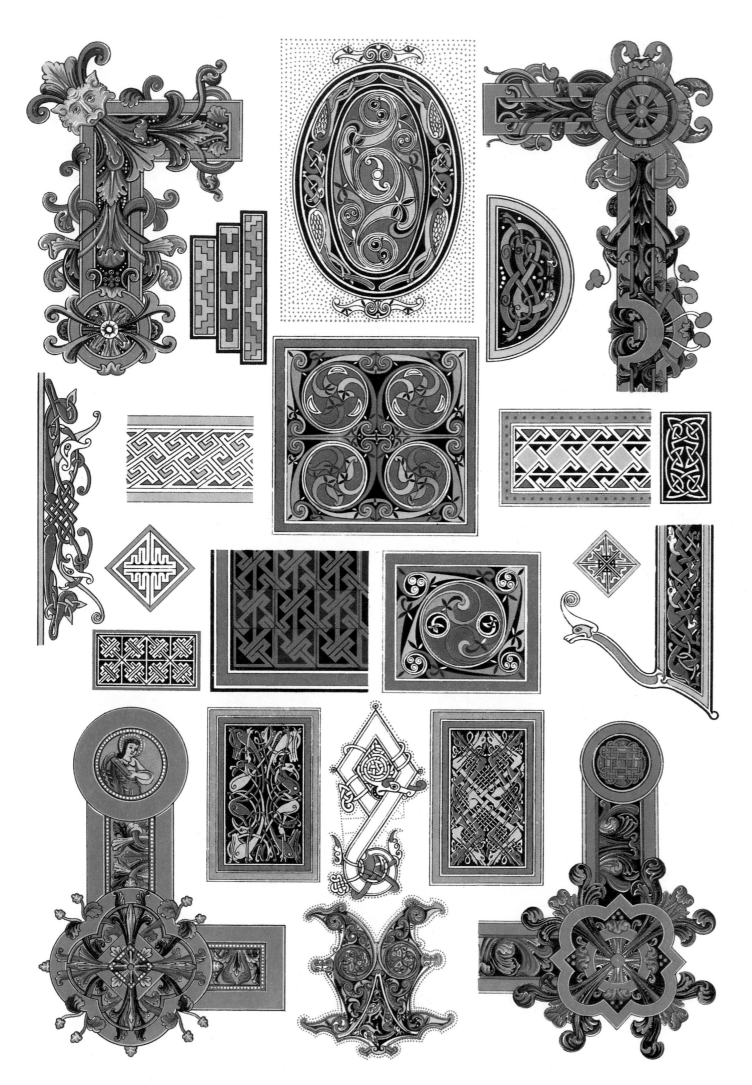

Plate LXV. Celtic Ornament.

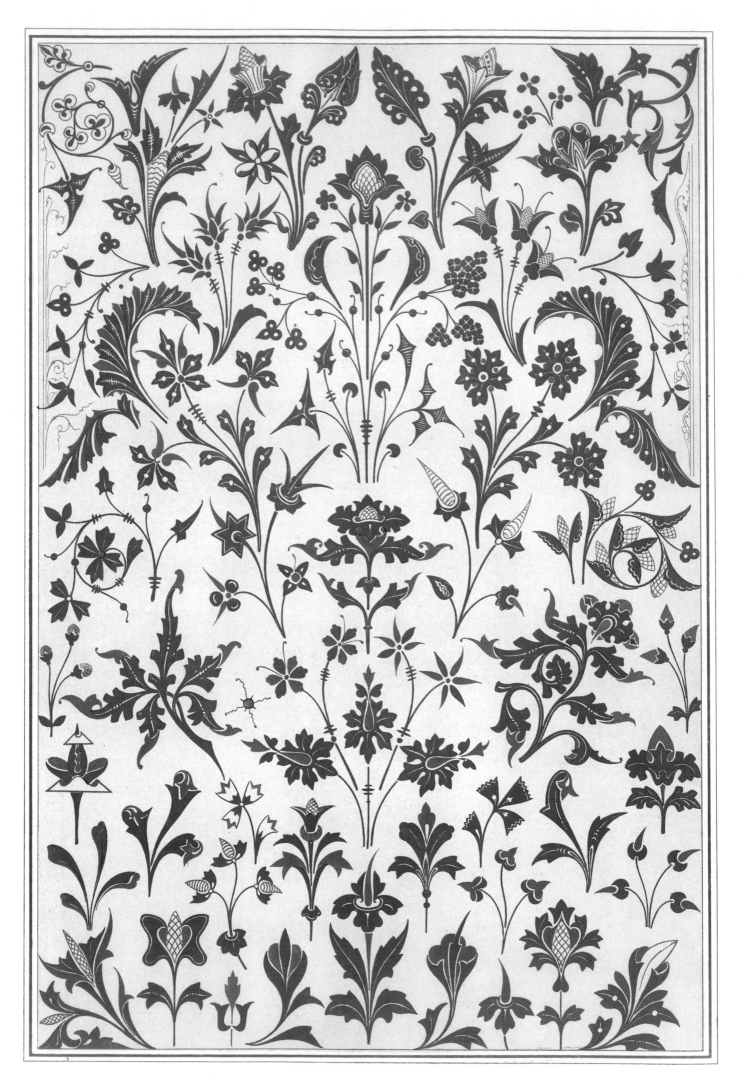

Plate LXVI. Medieval Ornament.

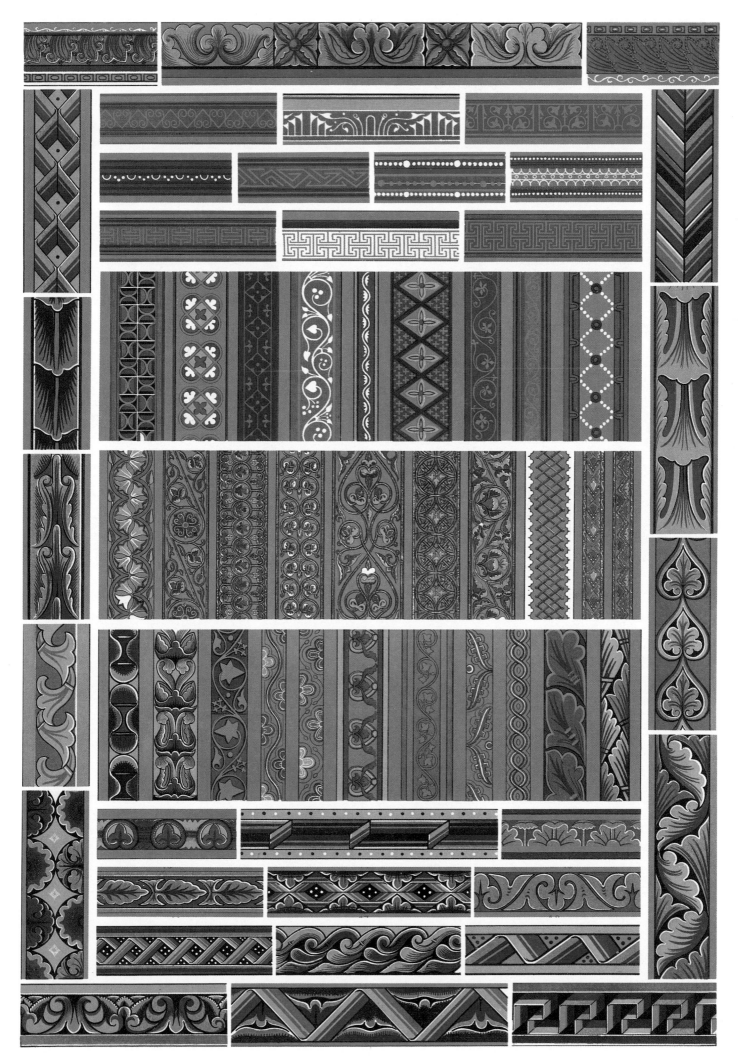

Plate LXVII. Medieval Ornament.

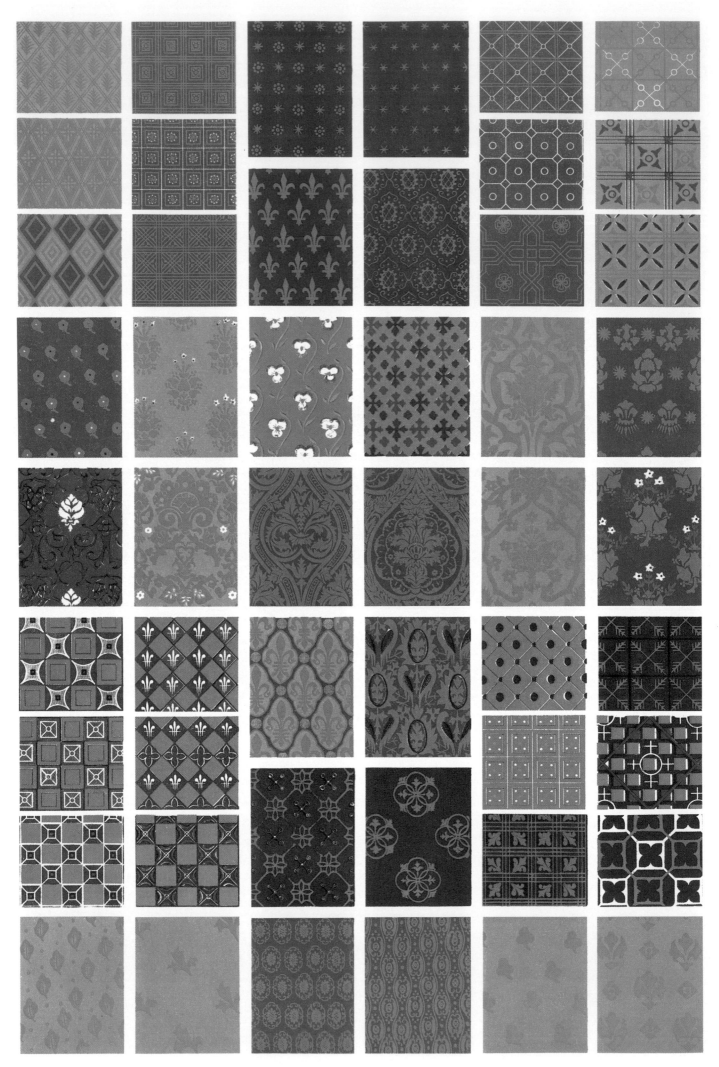

Plate LXVIII. Medieval Ornament.

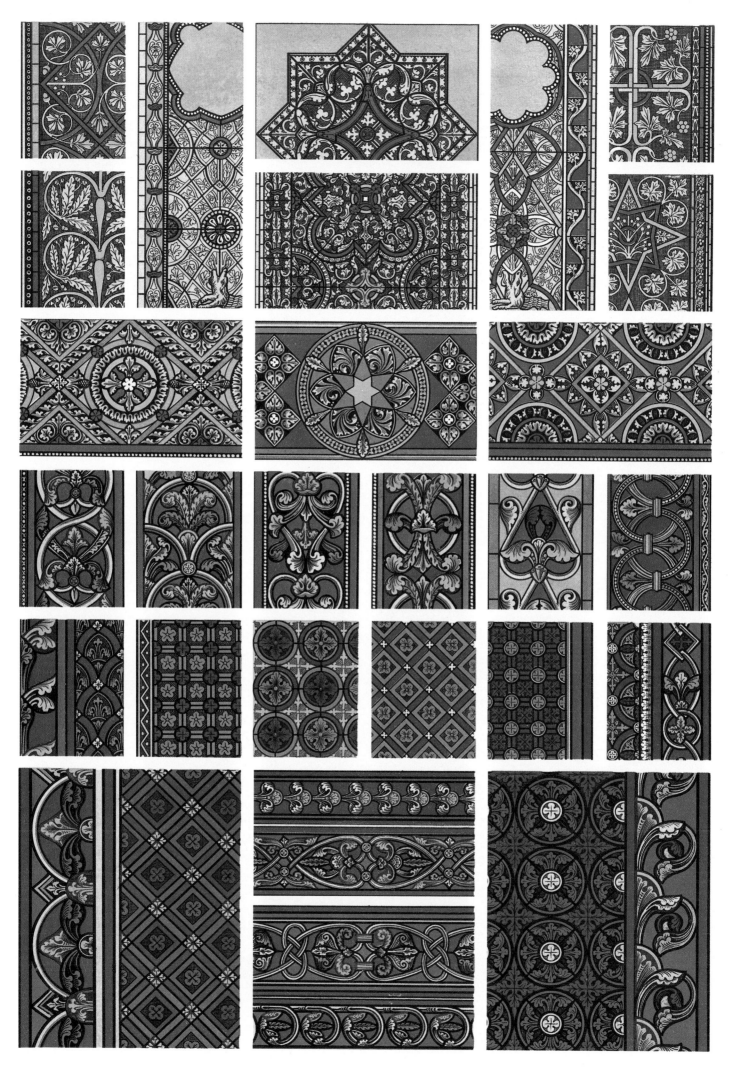

Plate LXIX. Medieval Ornament.

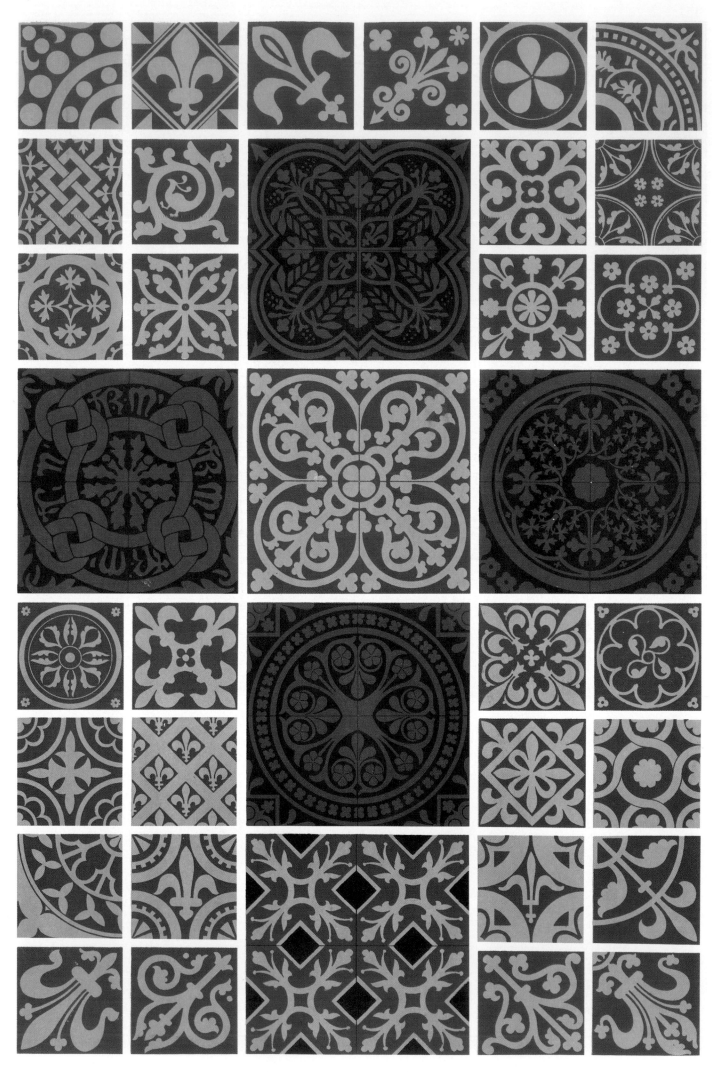

Plate LXX. MEDIEVAL ORNAMENT.

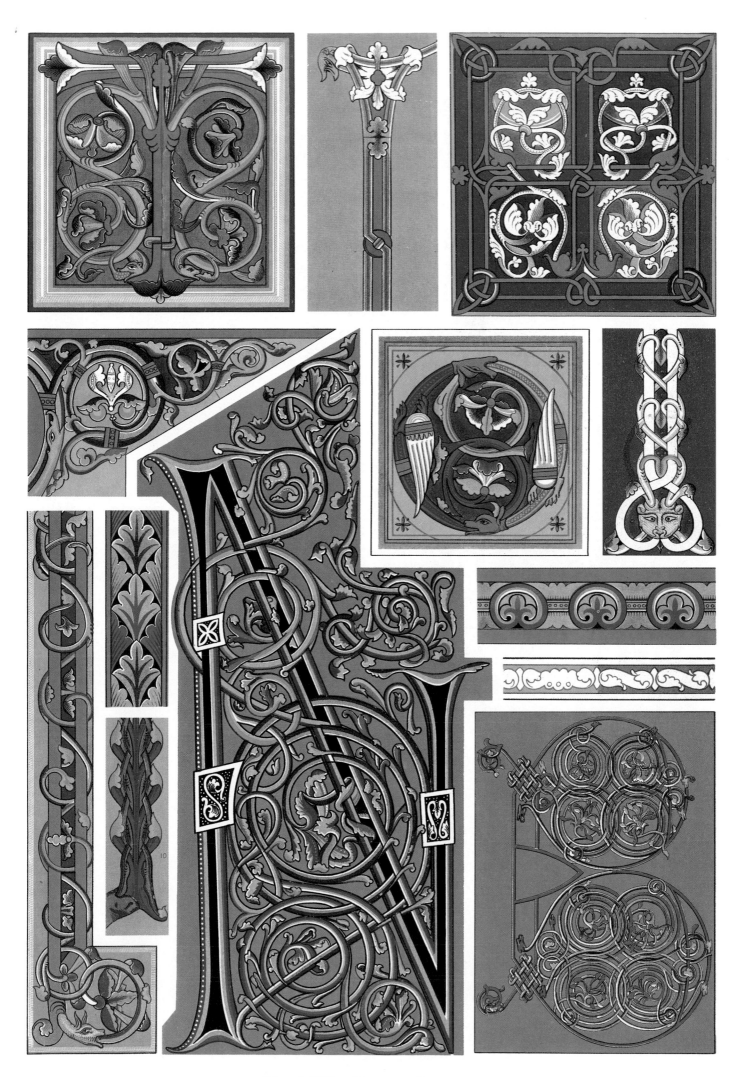

Plate LXXI. MEDIEVAL ORNAMENT.

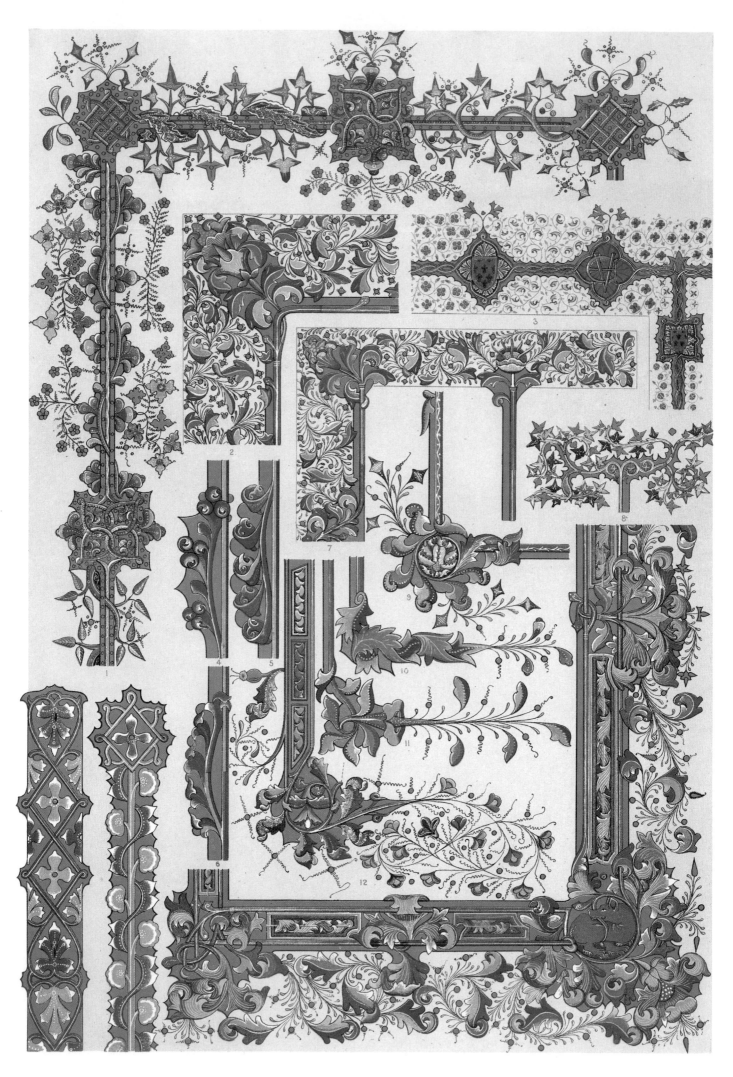

Plate LXXII. Medieval Ornament.

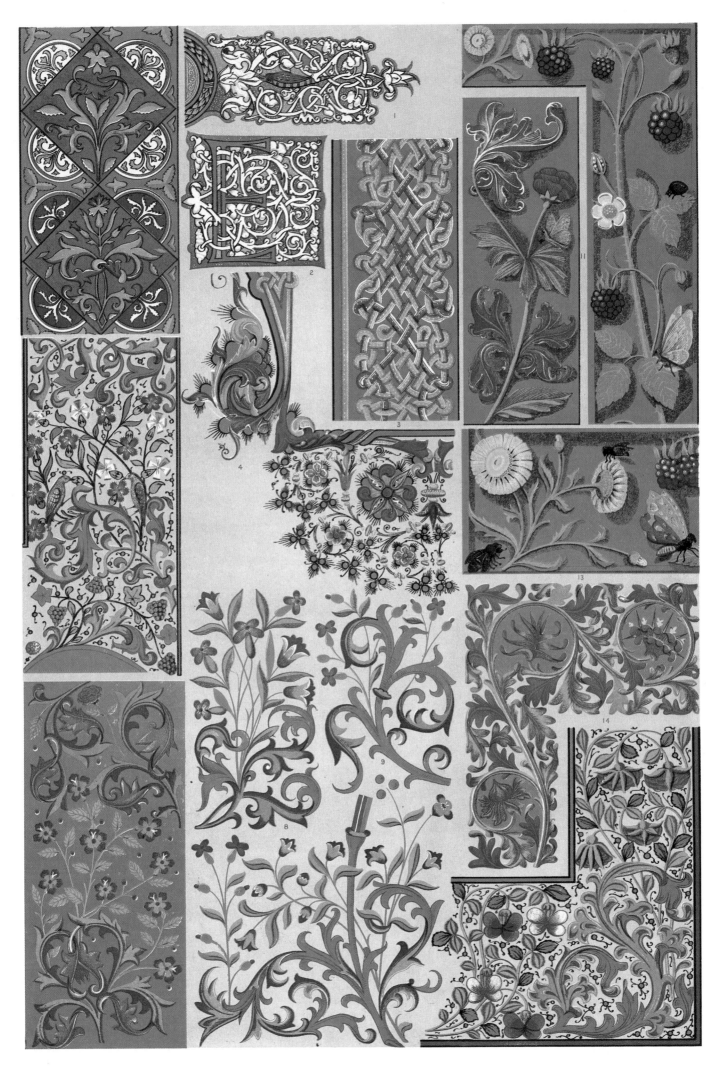

Plate LXXIII. Medieval Ornament.

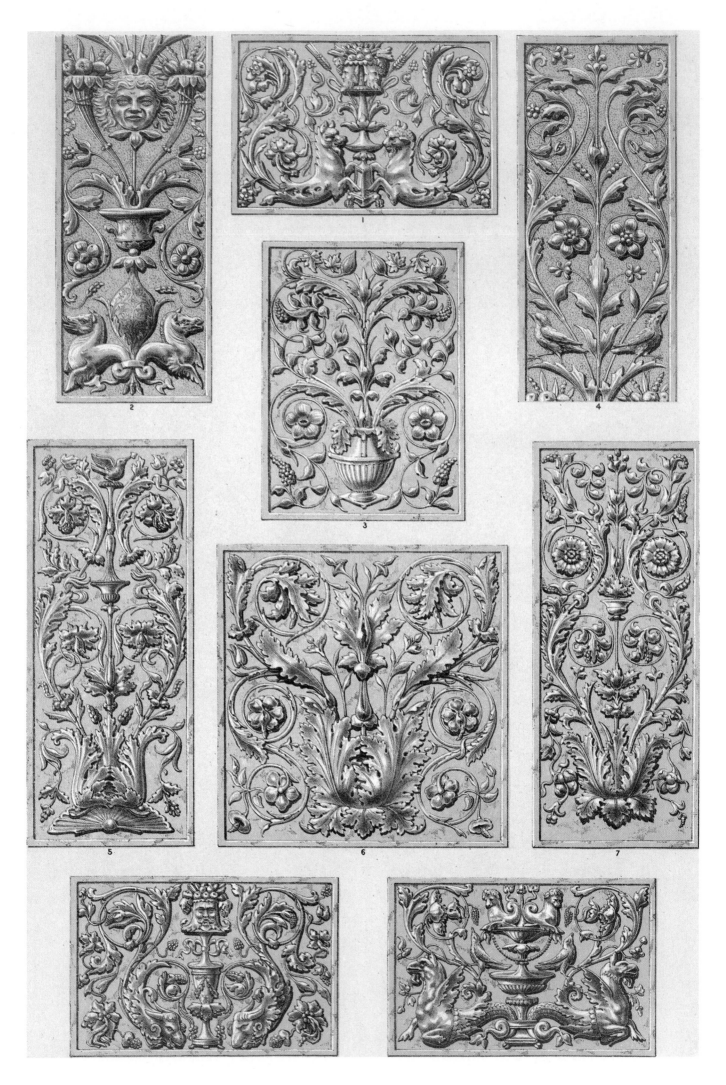

Plate LXXIV. RENAISSANCE ORNAMENT.

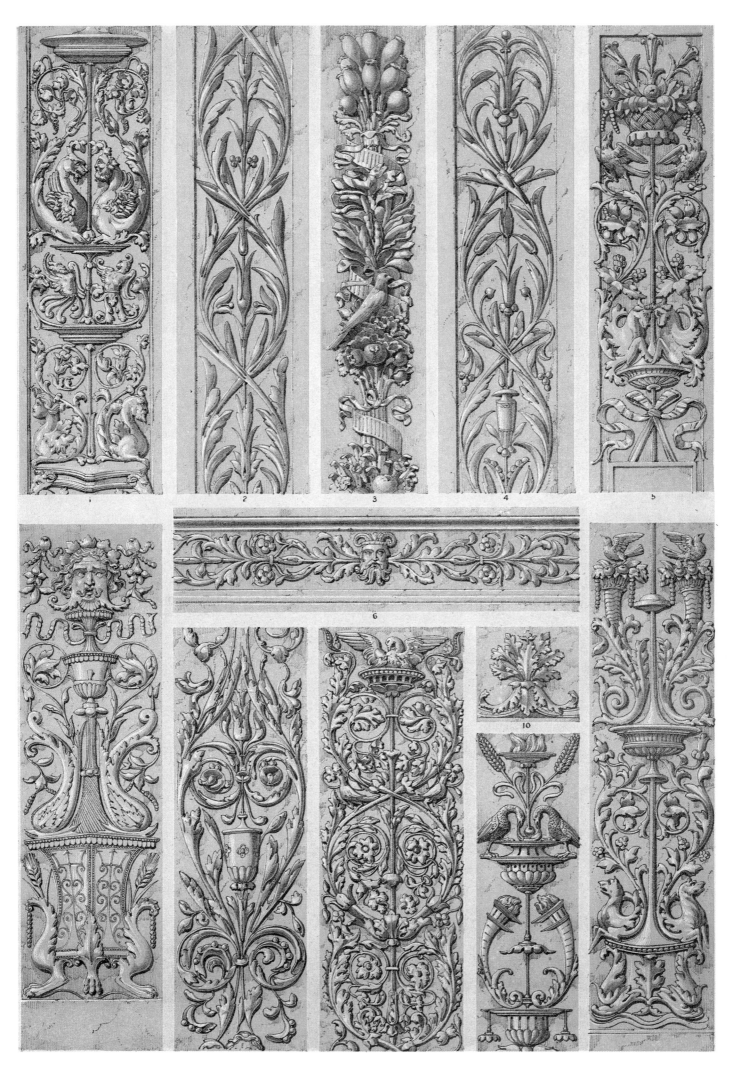

Plate LXXV. Renaissance Ornament.

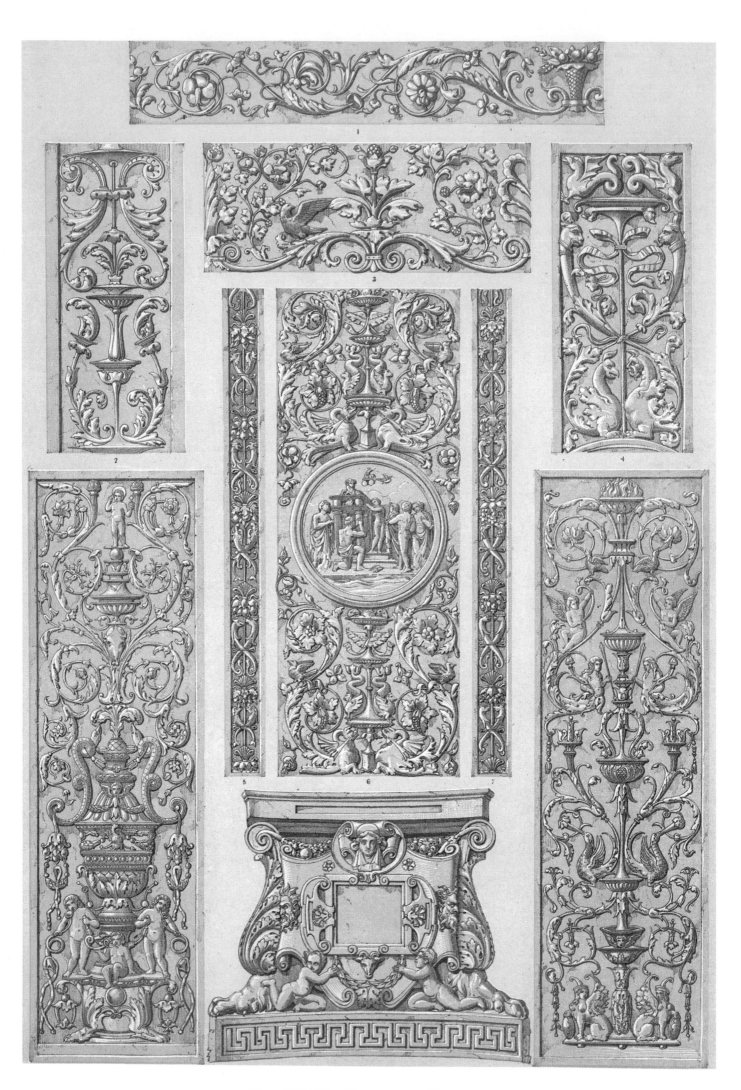

Plate LXXVI. RENAISSANCE ORNAMENT.

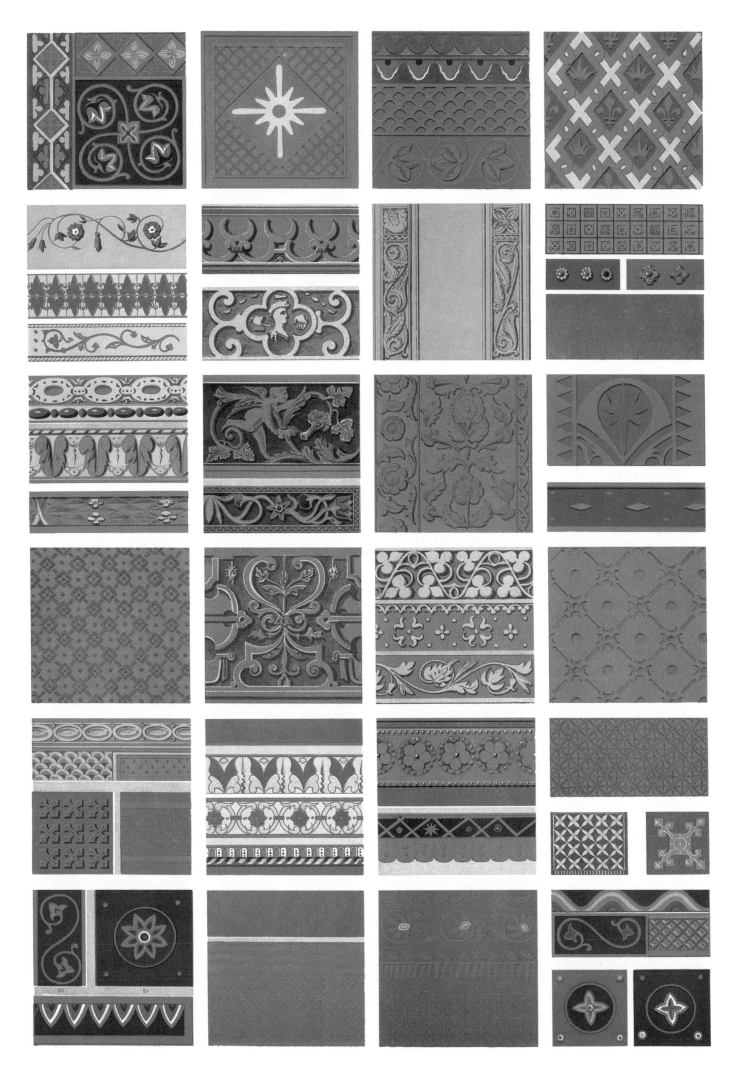

Plate LXXVII. Renaissance Ornament.

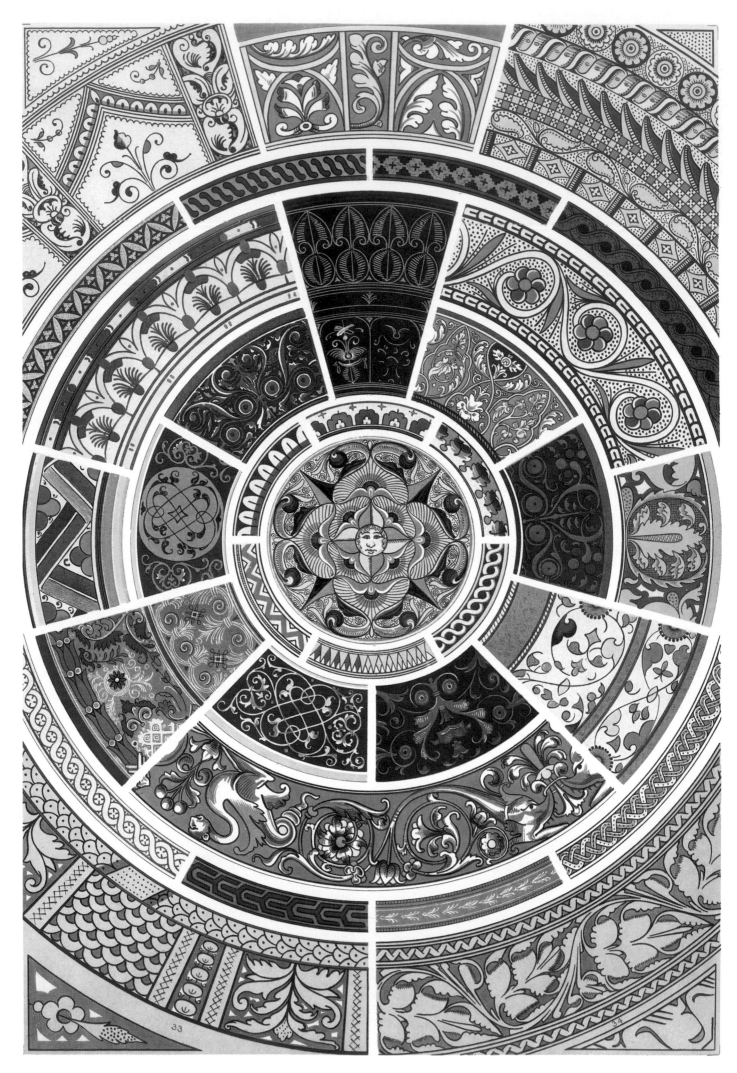

Plate LXXVIII. Renaissance Ornament.

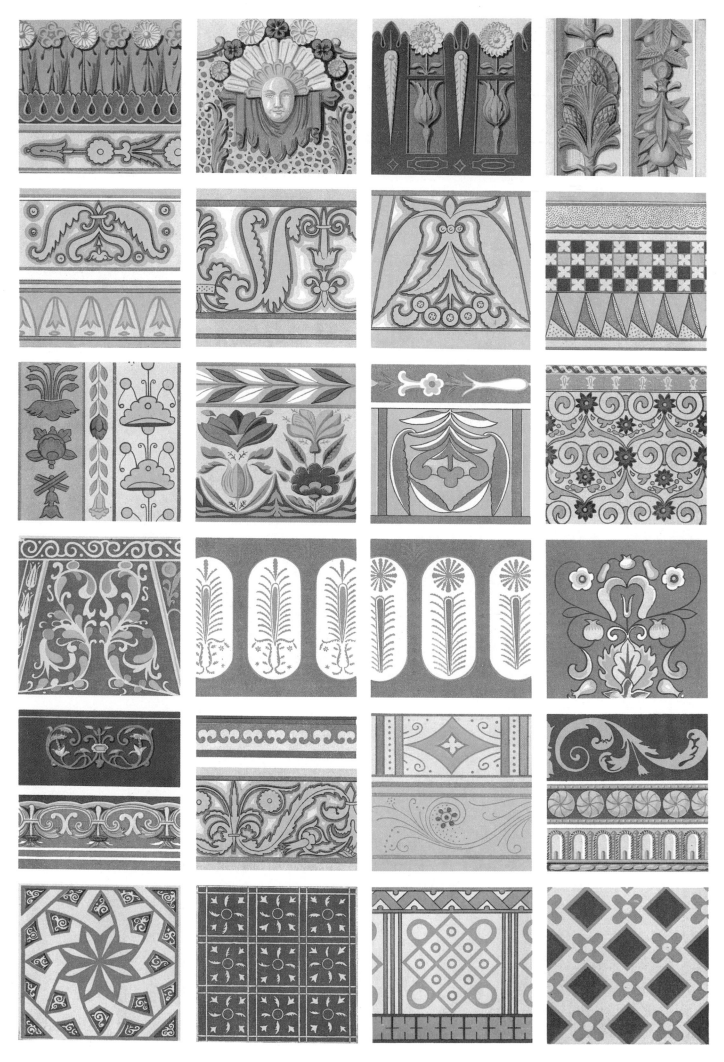

Plate LXXIX. Renaissance Ornament.

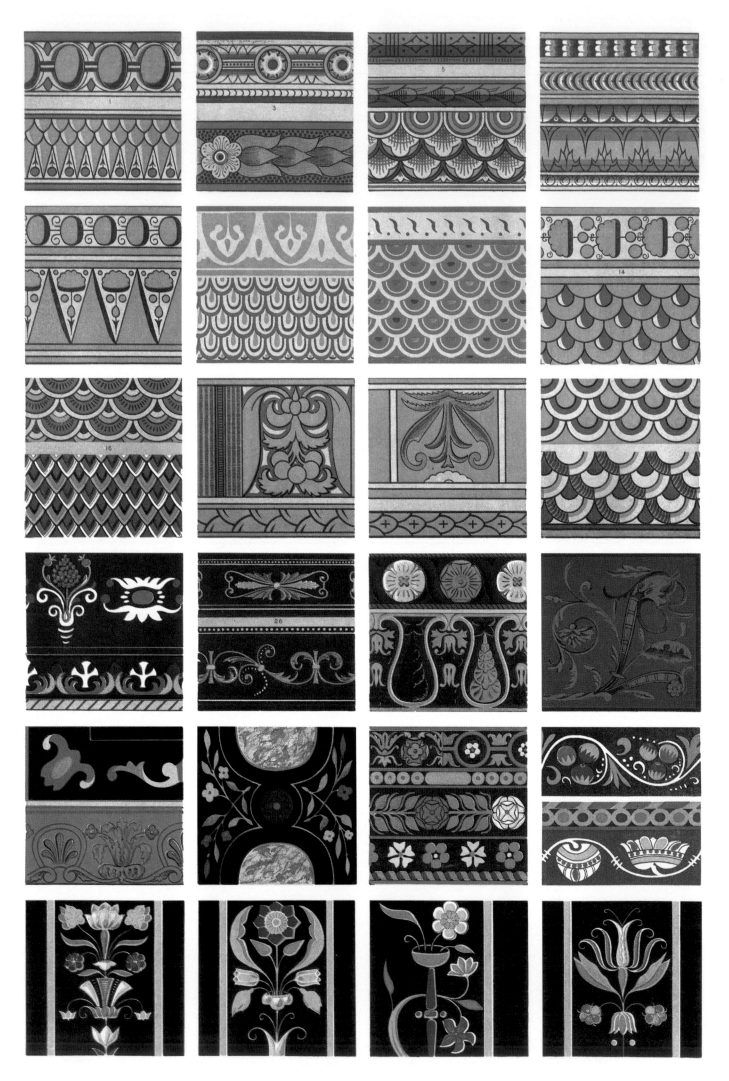

Plate LXXX. RENAISSANCE ORNAMENT.

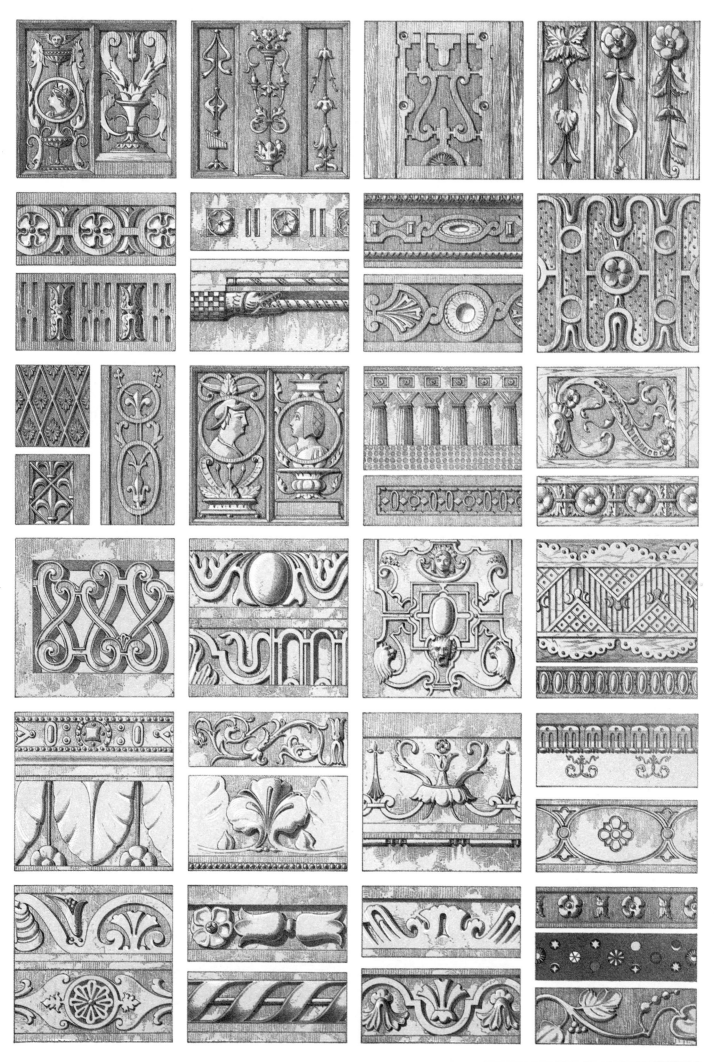

Plate LXXXI. Renaissance Ornament.

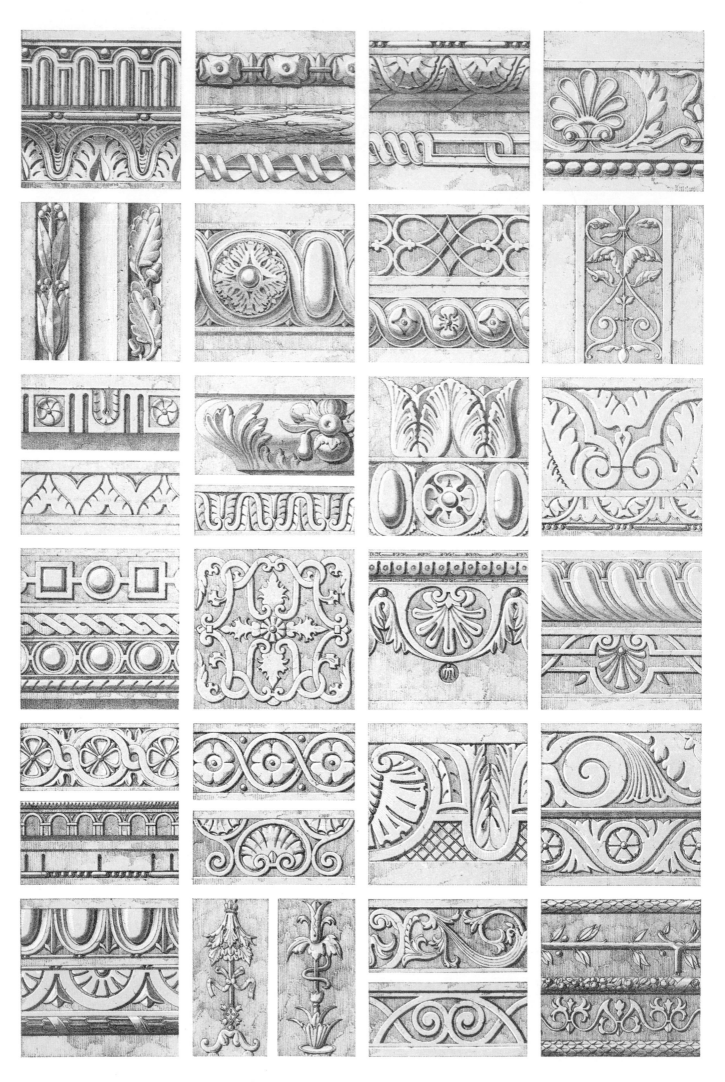

Plate LXXXII. Renaissance Ornament.

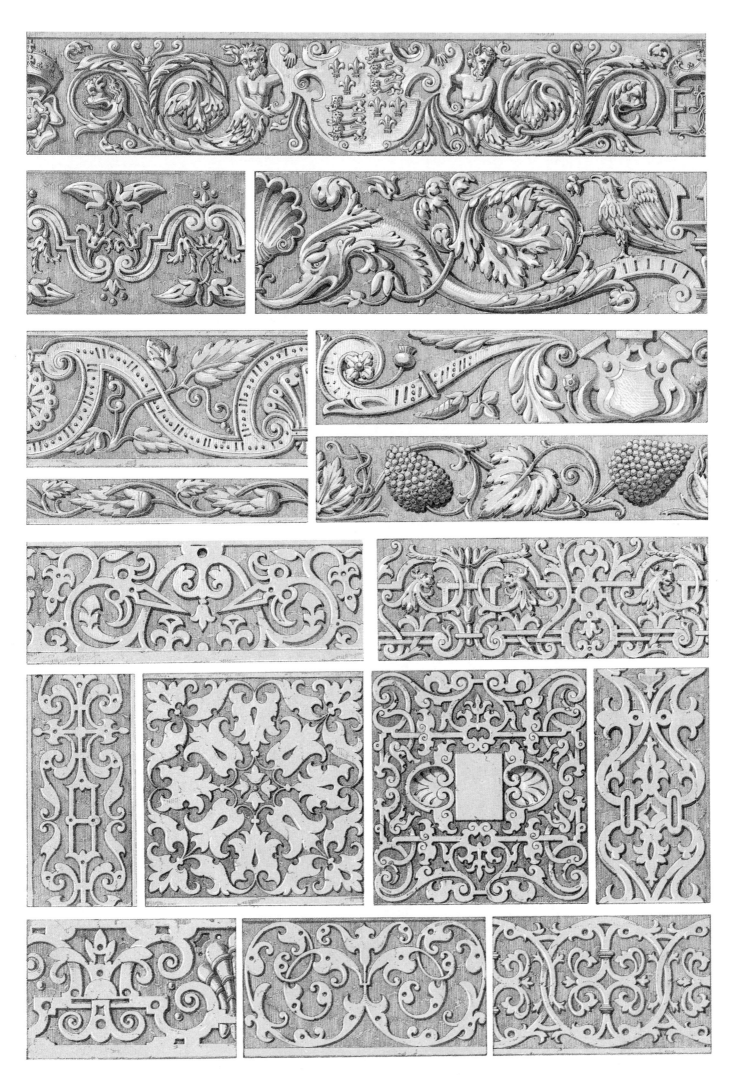

Plate LXXXIII. Elizabethan Ornament.

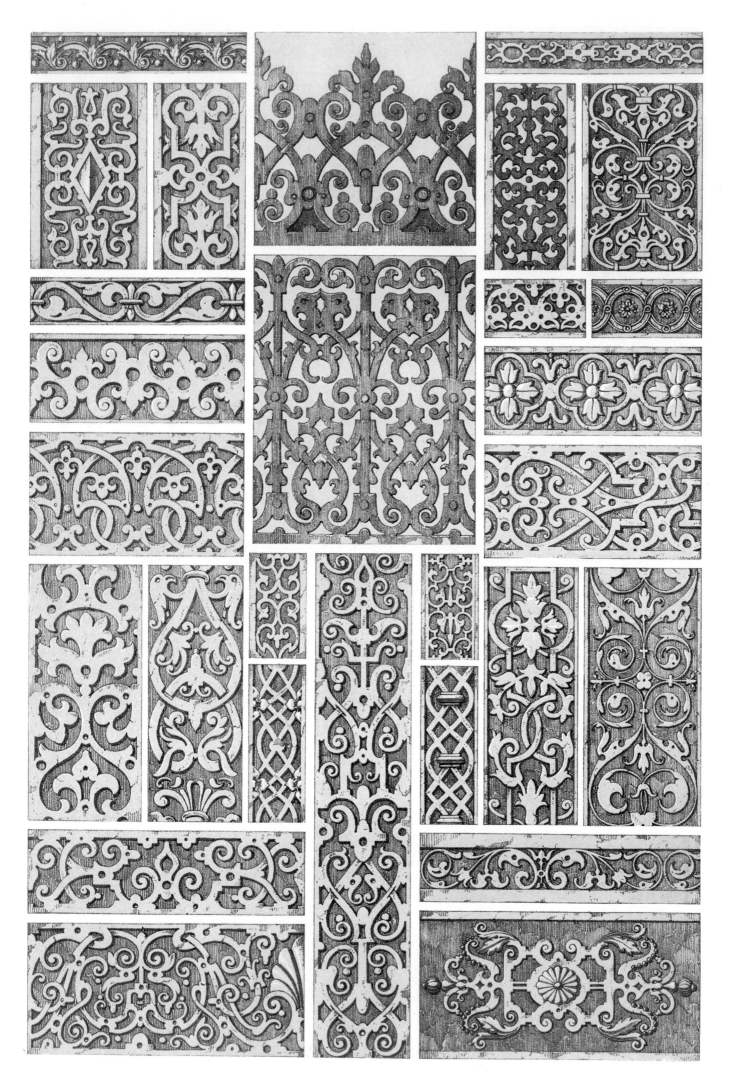

Plate LXXXIV. Elizabethan Ornament.

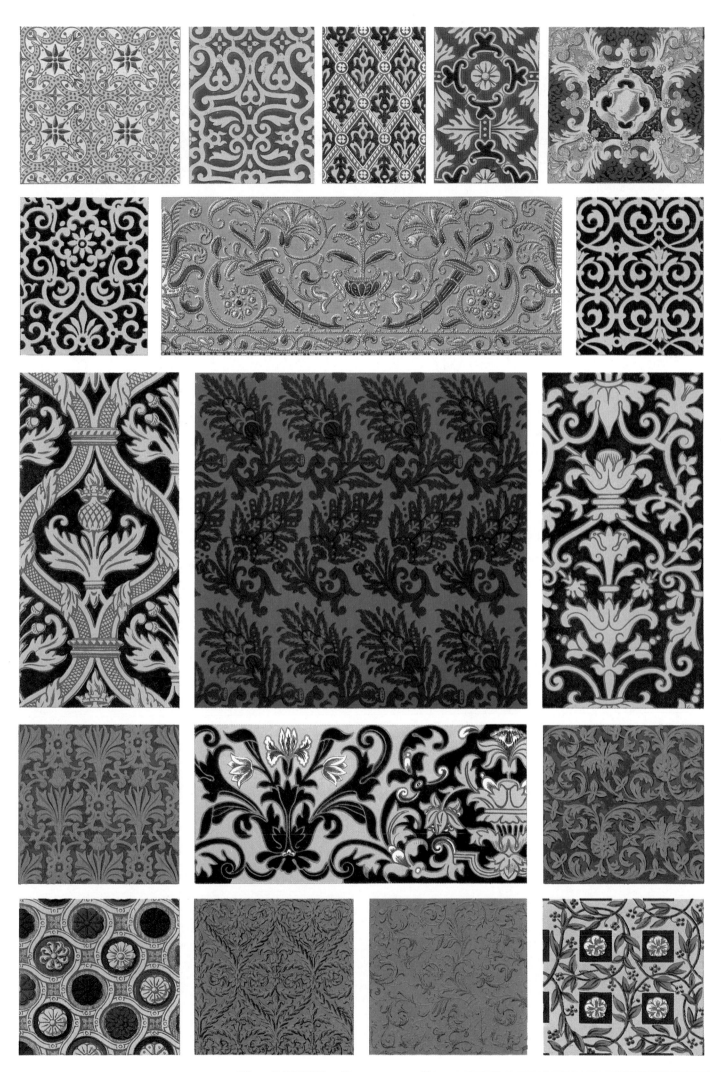

Plate LXXXV. ELIZABETHAN ORNAMENT.

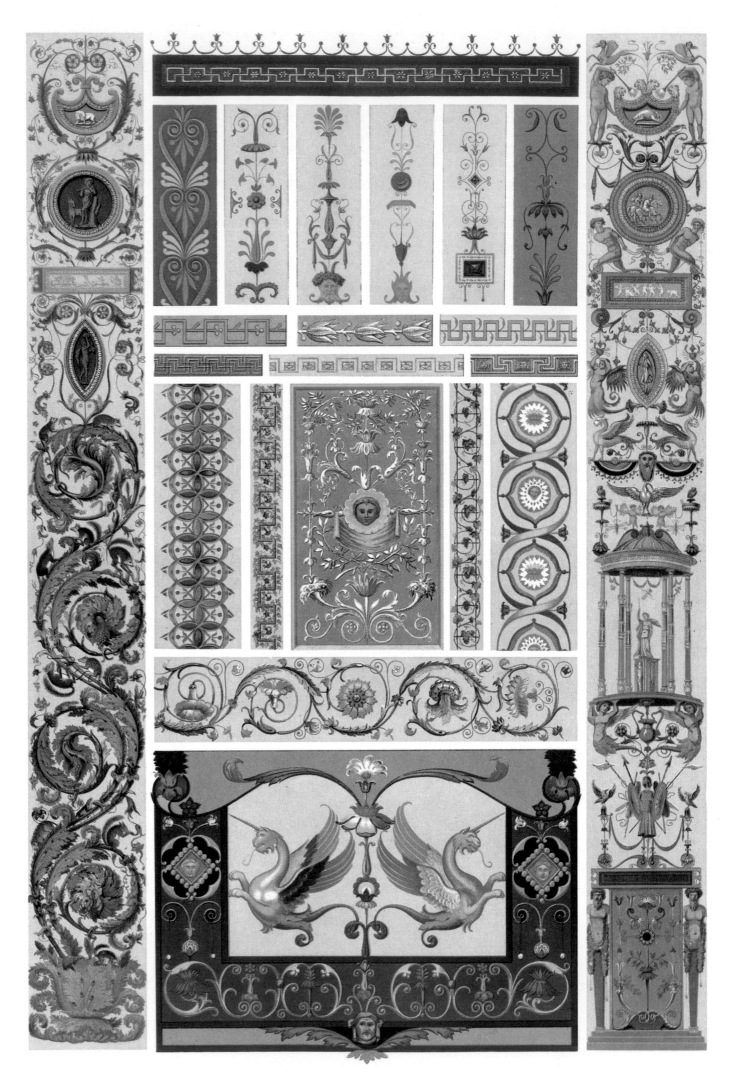

Plate LXXXVI. Italian Ornament.

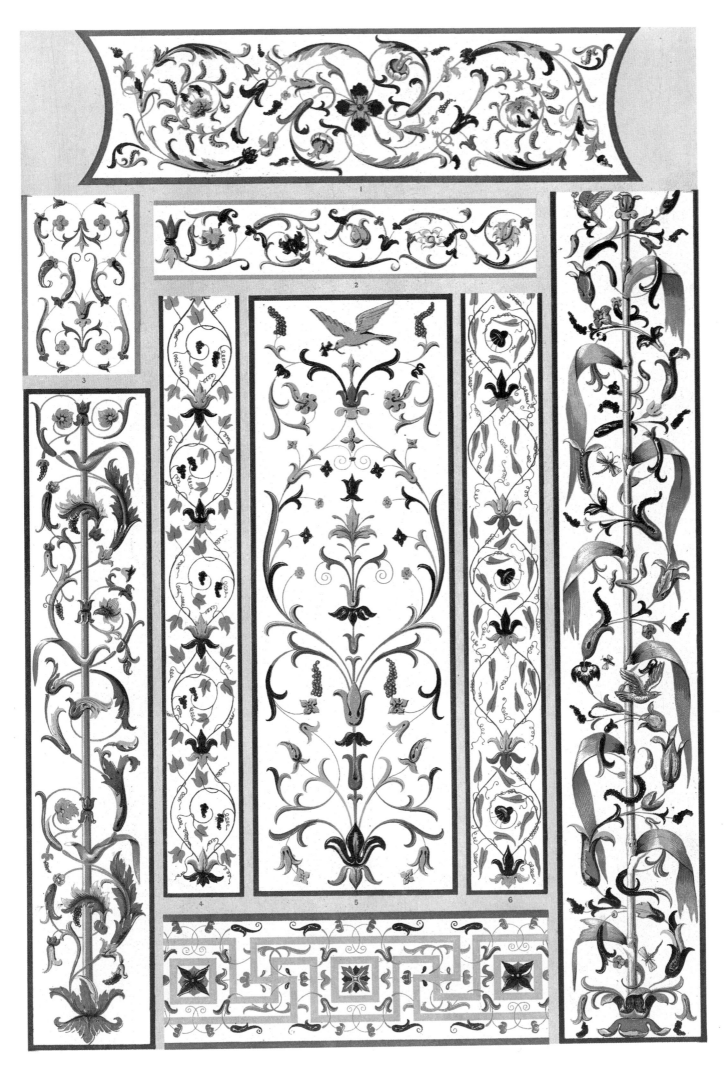

Plate LXXXVII. ITALIAN ORNAMENT.

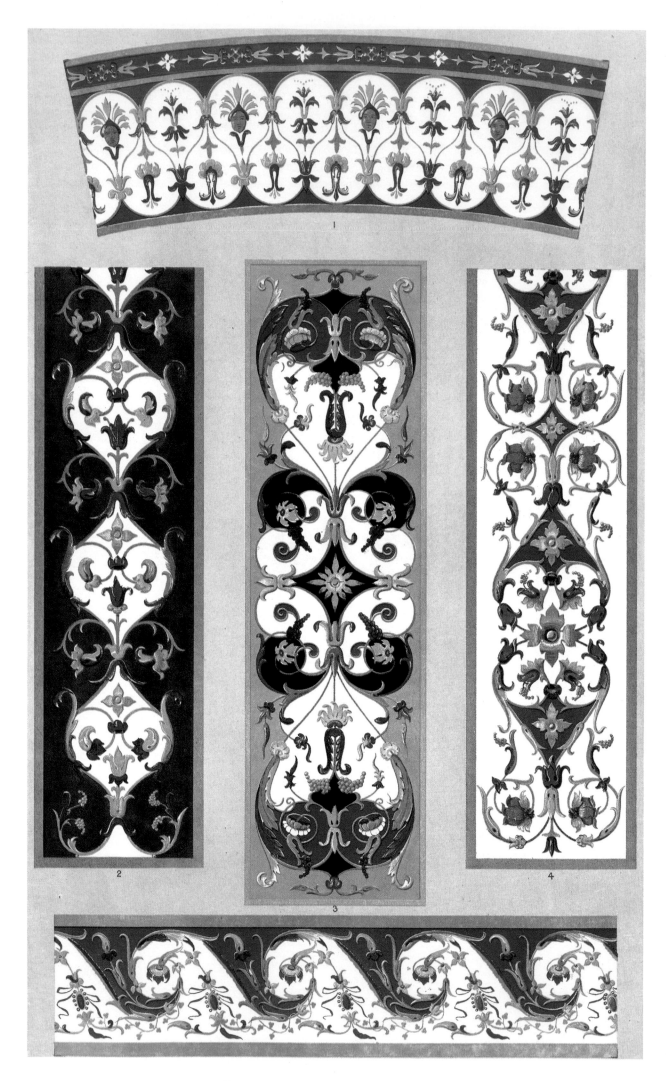

Plate LXXXVIII. Italian Ornament.

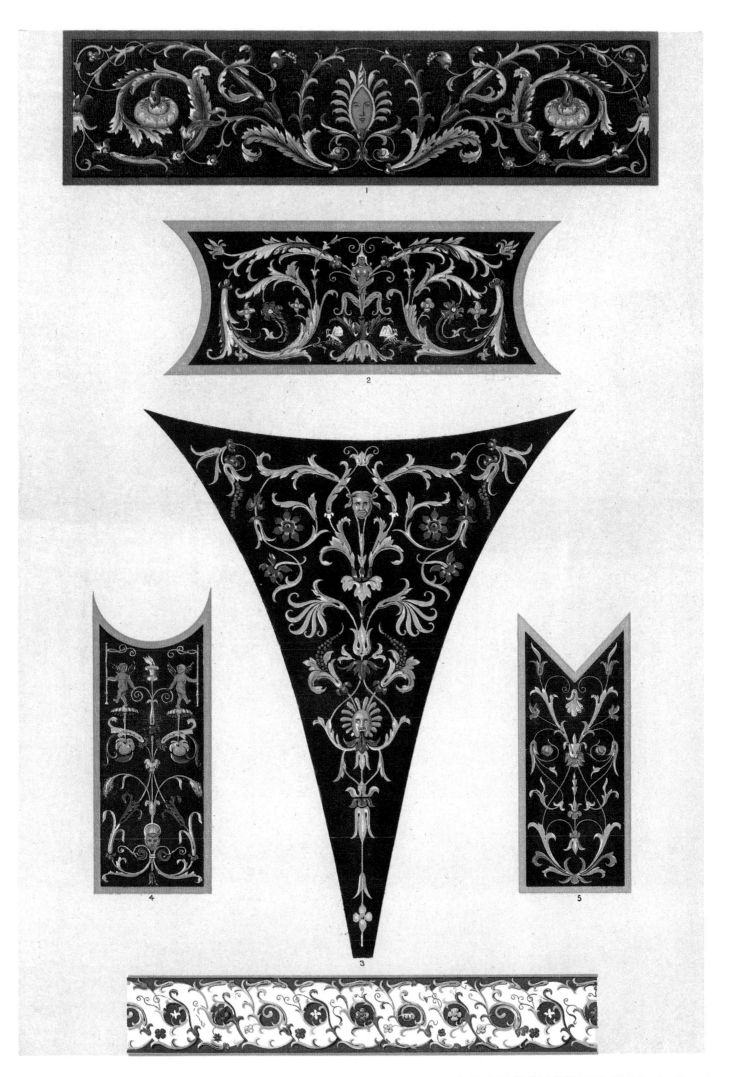

Plate LXXXIX. ITALIAN ORNAMENT.

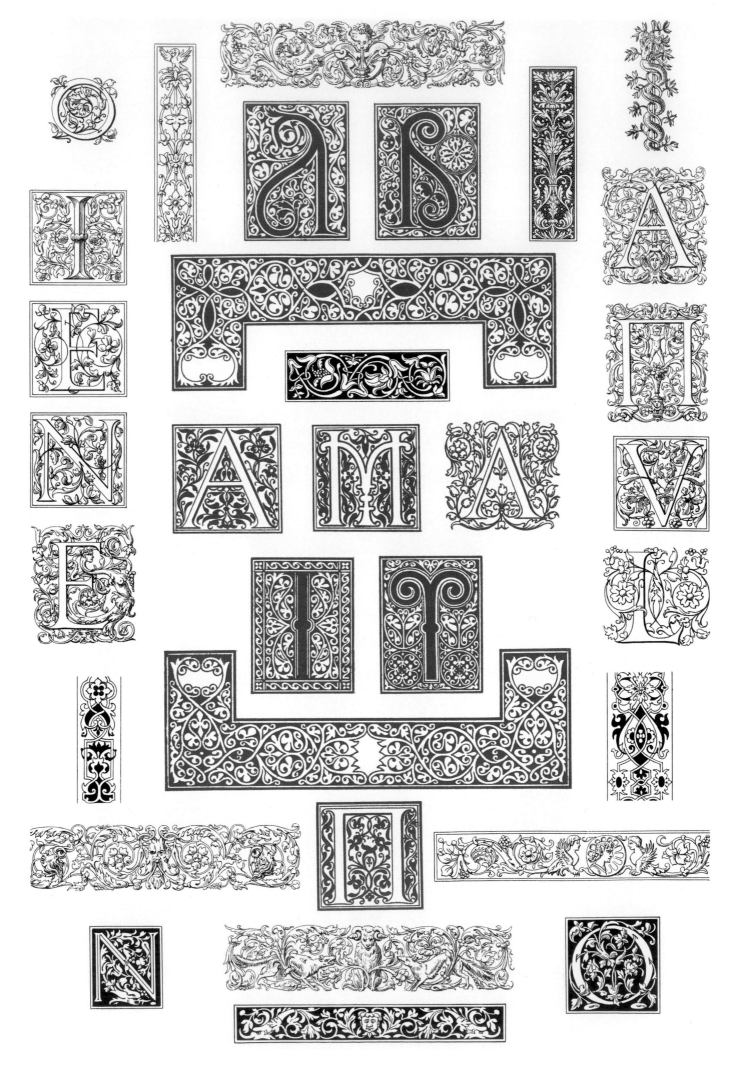

Plate XC. Italian Ornament.

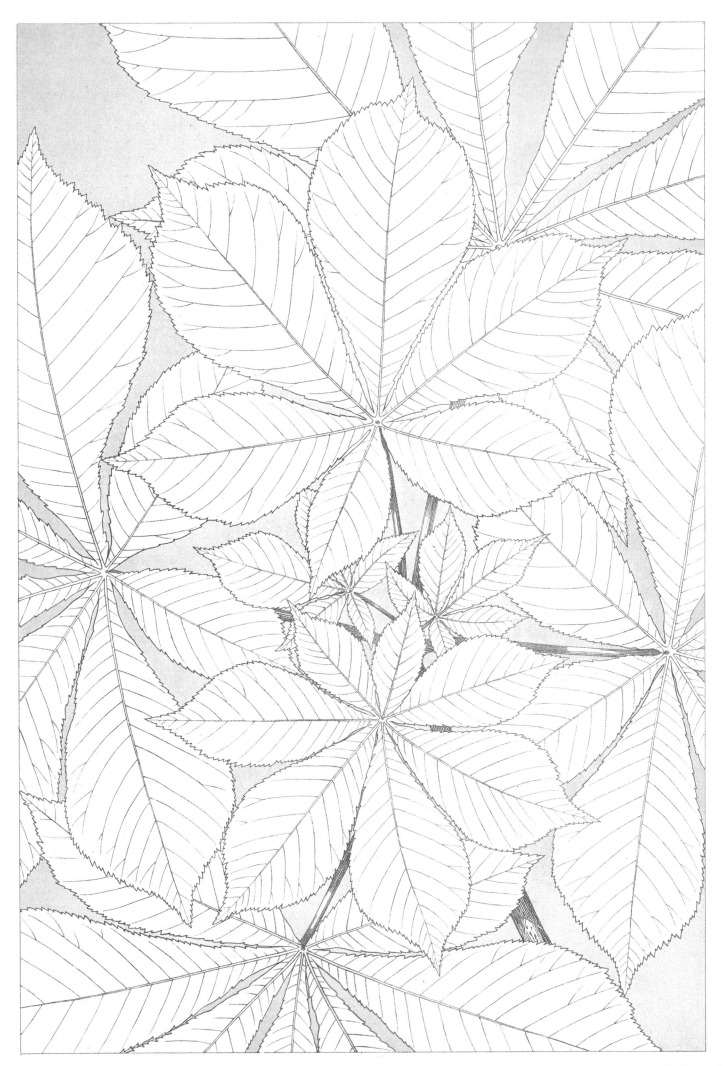

Plate XCI. Leaves and Flowers from Nature.

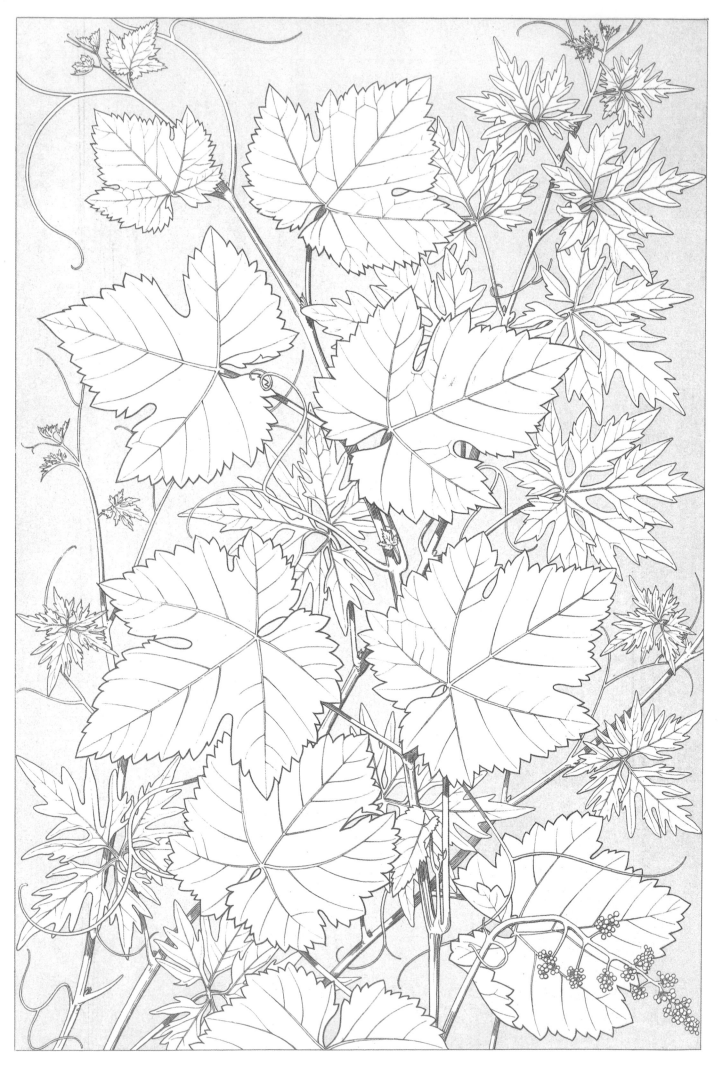

Plate XCII. LEAVES AND FLOWERS FROM NATURE.

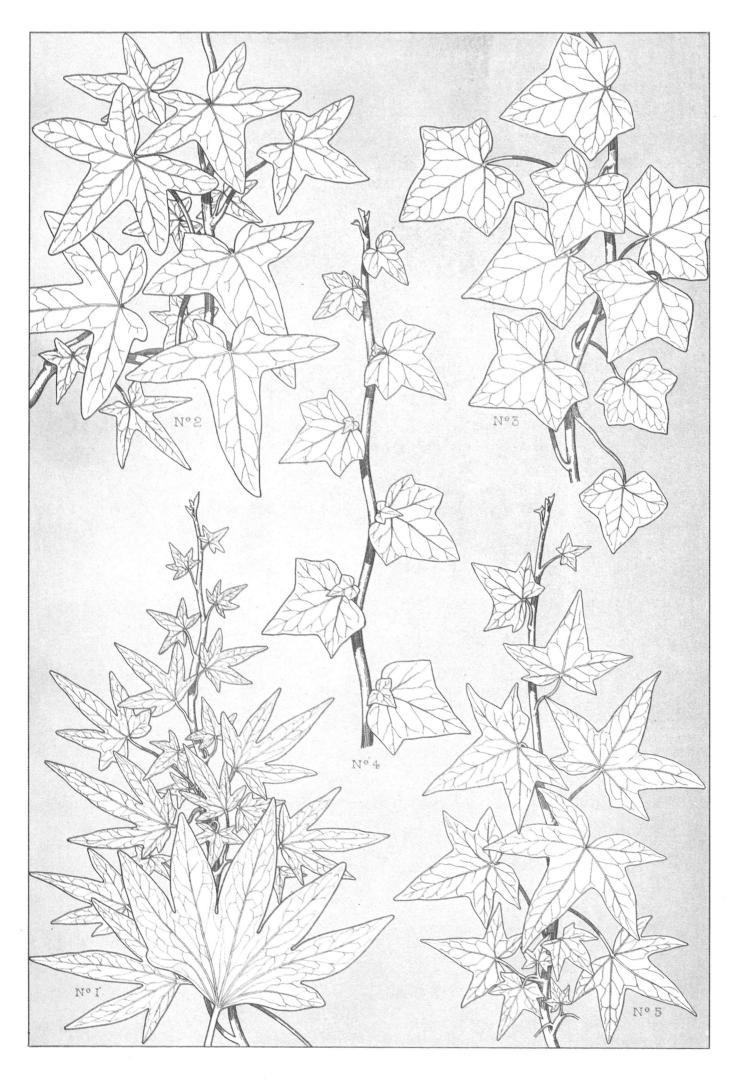

N°2 N°3 N°4 N°1 N°5

Plate XCIII. Leaves and Flowers from Nature.

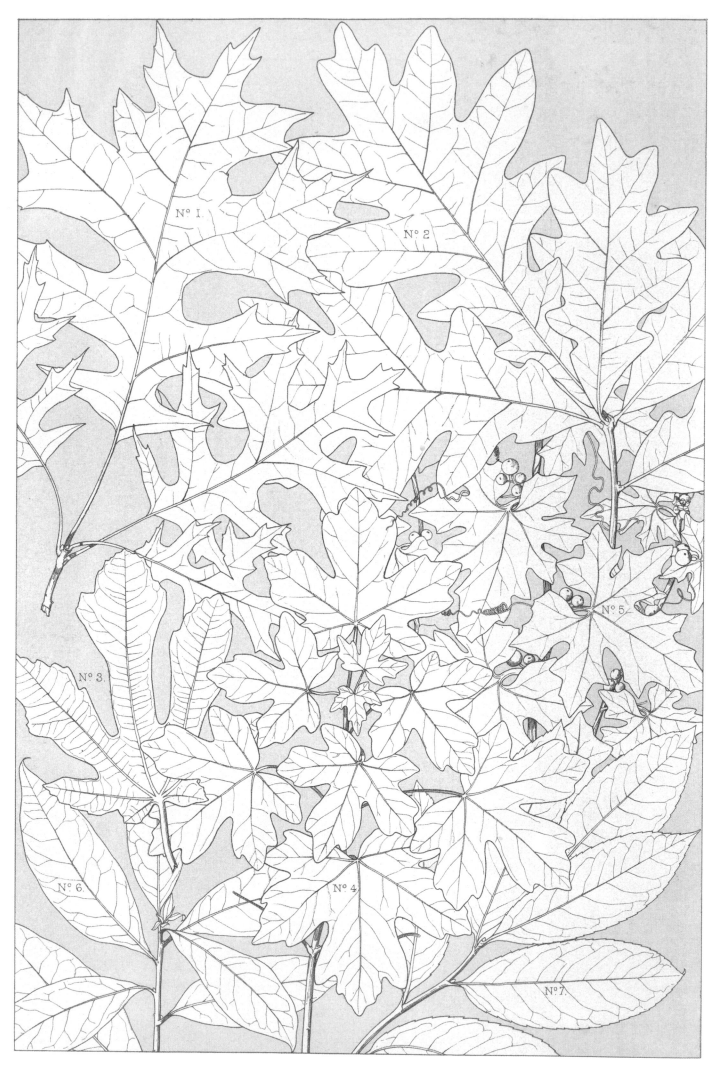

Plate XCIV. Leaves and Flowers from Nature.

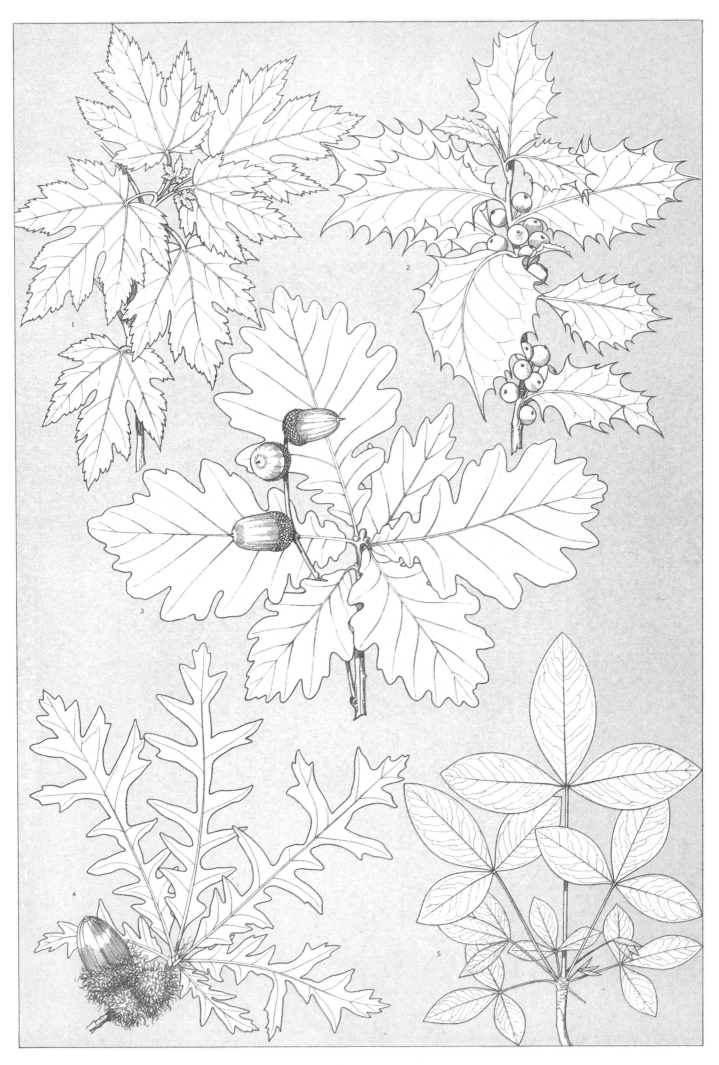

Plate XCV. LEAVES AND FLOWERS FROM NATURE.

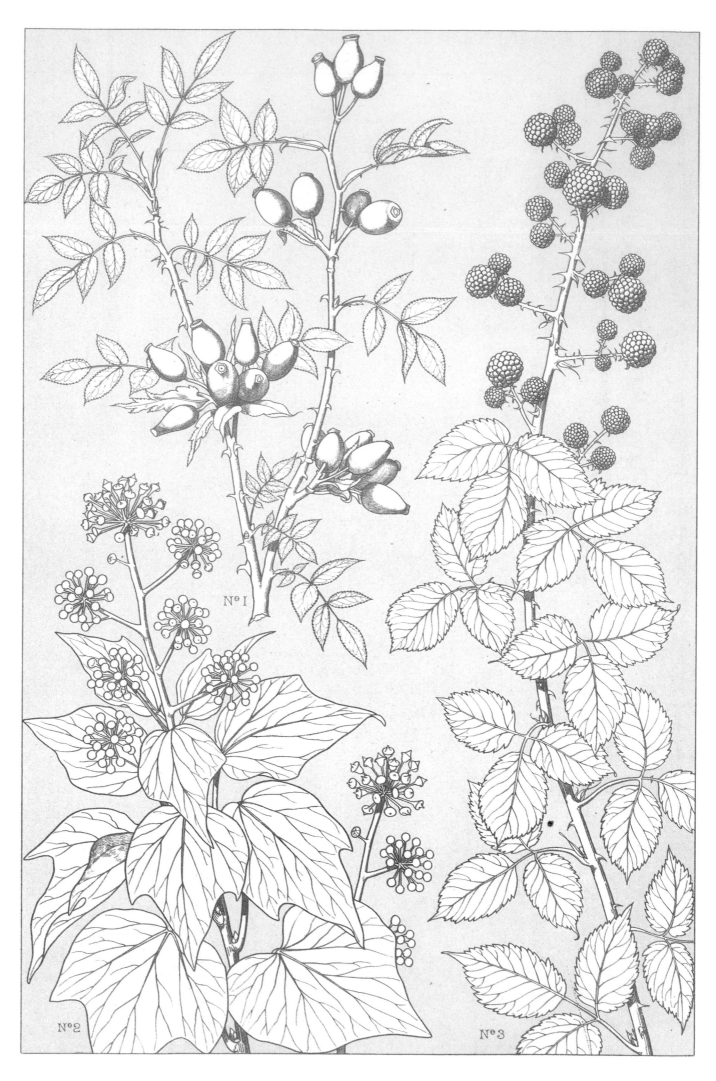

Nº I

Nº 2

Nº 3

Plate XCVI. LEAVES AND FLOWERS FROM NATURE.

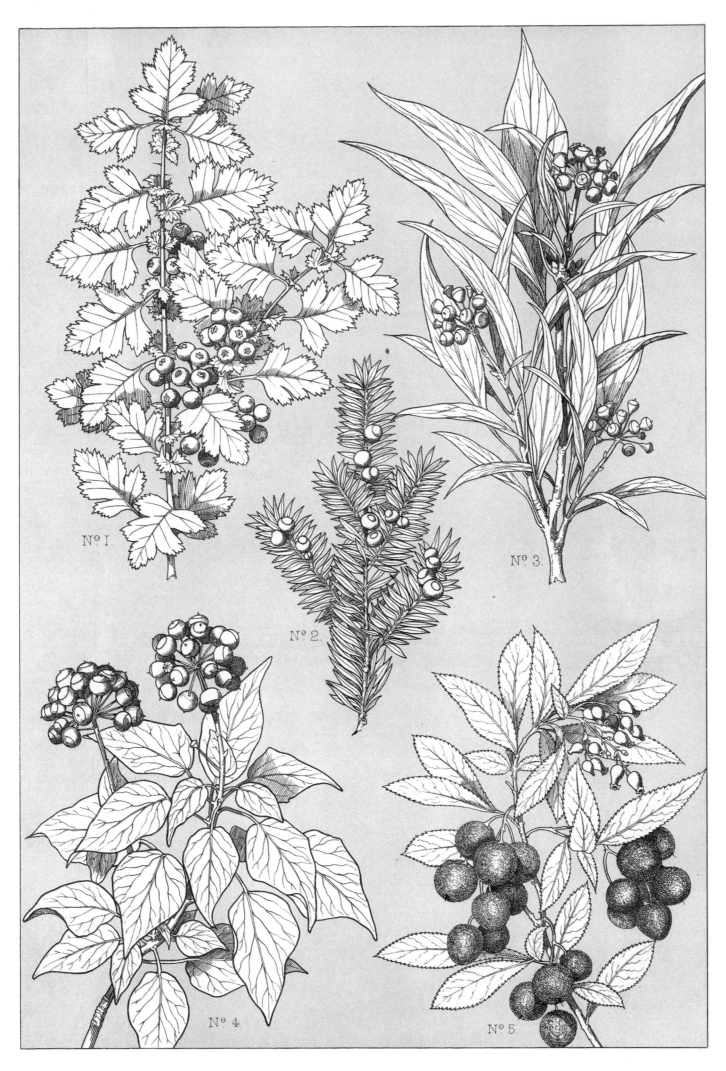

Nº 1.

Nº 2.

Nº 3.

Nº 4.

Nº 5.

Plate XCVII. LEAVES AND FLOWERS FROM NATURE.

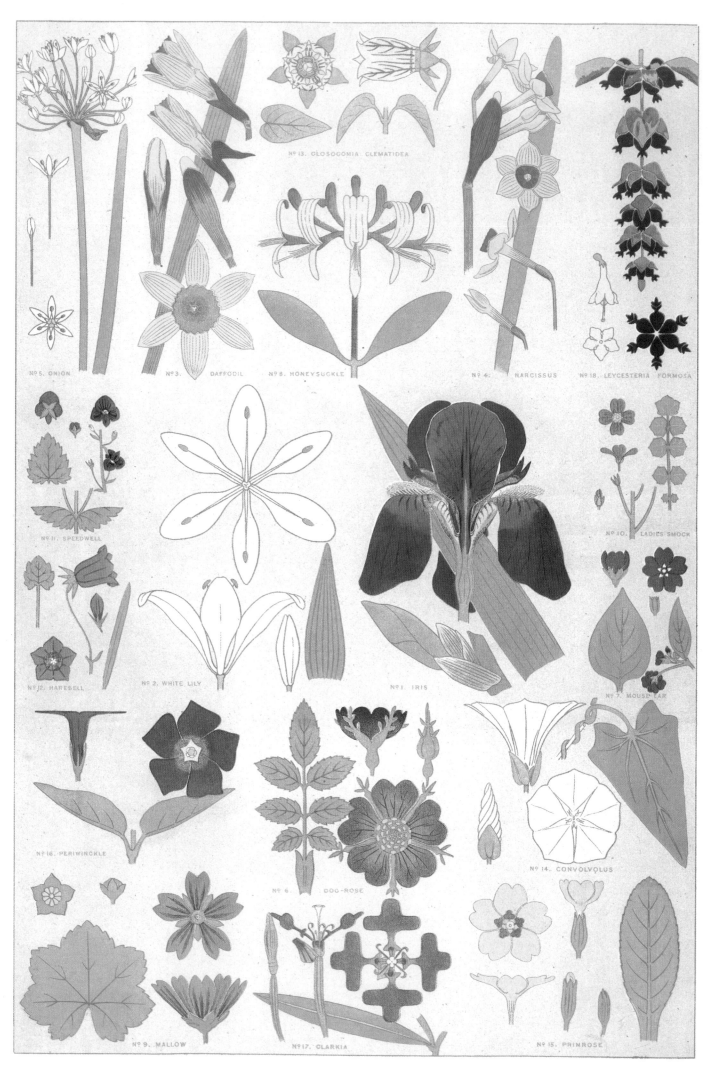

Nº 13. CLOSOGOMIA CLEMATIDEA

Nº 5. ONION Nº 3. DAFFODIL Nº 8. HONEYSUCKLE Nº 4. NARCISSUS Nº 18. LEYCESTERIA FORMOSA

Nº 11. SPEEDWELL Nº 10. LADIES SMOCK

Nº 12. HAREBELL Nº 2. WHITE LILY Nº 1. IRIS Nº 7. MOUSE-EAR

Nº 16. PERIWINKLE Nº 14. CONVOLVULUS

Nº 6. DOG-ROSE

Nº 9. MALLOW Nº 17. CLARKIA Nº 15. PRIMROSE

Plate XCVIII. Leaves and Flowers from Nature.

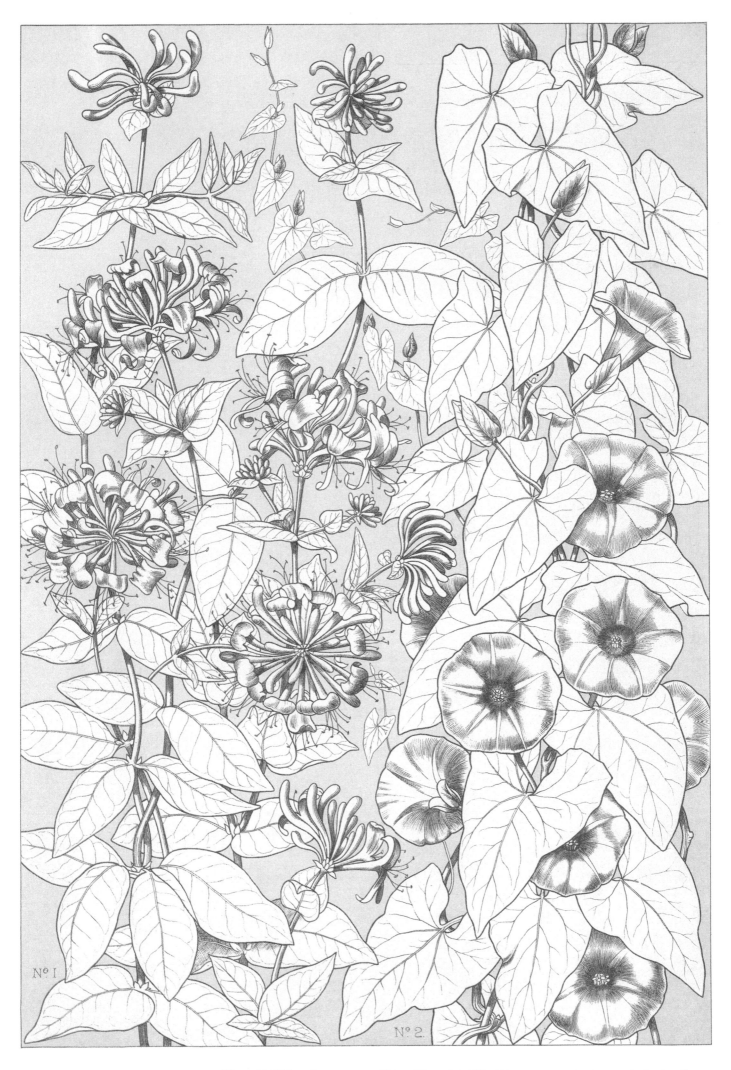

Plate XCIX. Leaves and Flowers from Nature.

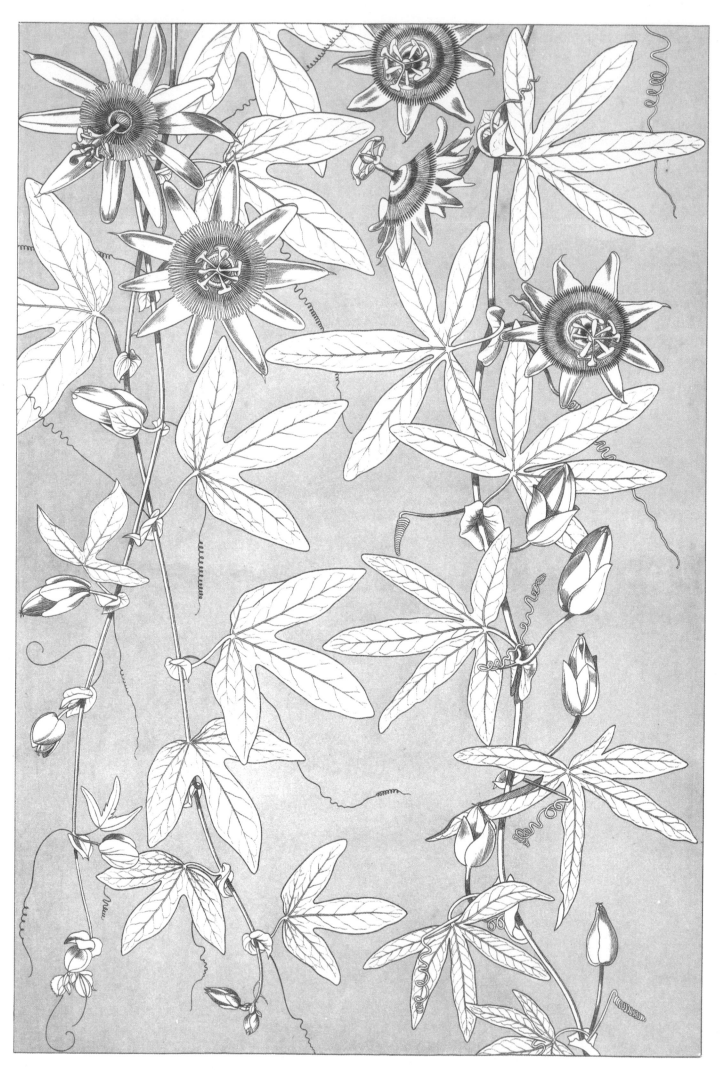

Plate C. Leaves and Flowers from Nature.